Drawing for the Absolute Beginner

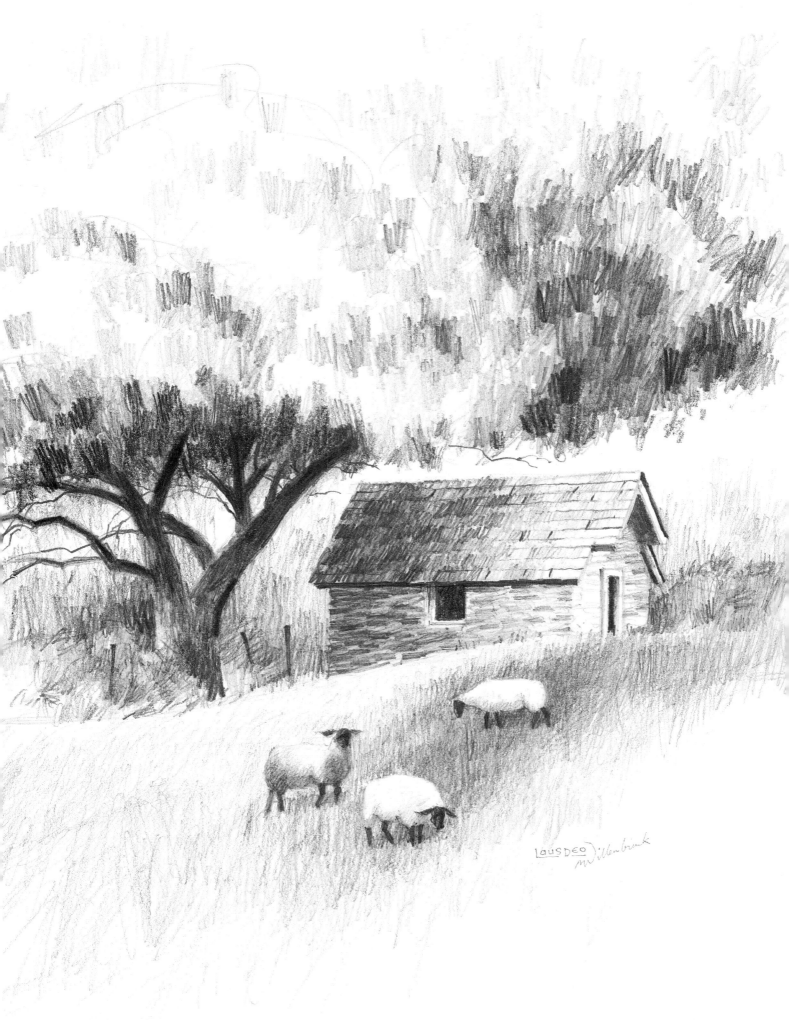

drawing for the
absolute beginner

A Clear & Easy Guide to
Successful Drawing

Mark and Mary
Willenbrink

NORTH LIGHT BOOKS
CINCINNATI, OHIO
www.artistsnetwork.com

About the Authors

Mark Willenbrink is a freelance illustrator and fine artist whose work has been displayed in fine art shows, with several paintings receiving awards. Mark also teaches art classes and workshops using demonstration, simple instructions and professional tricks to help his students achieve beautiful artwork they can be proud to display.

Mary Willenbrink has her master's degree. She is a Christian counselor and author, but feels her highest calling is to be home to raise her children.

As a husband and wife team, Mark and Mary have authored and illustrated *Watercolor for the Absolute Beginner* (North Light, 2003), and the book has been translated into several languages. Mark's writings and illustrations have been featured in a number of other art instruction books. Mark is a contributing editor for *Watercolor Magic Magazine*. His regularly featured column, "Brush Basics" has been rated as a favorite among the magazine's readers.

Mark and Mary reside in Cincinnati, Ohio, with their three children.

Other fine North Light Books are available from your local bookstore, art supply store or direct from the publisher.

21 20 19 18 24 23 22

DISTRIBUTED IN CANADA BY FRASER DIRECT
100 Armstrong Avenue
Georgetown, ON, Canada L7G 5S4
Tel: (905) 877-4411

DISTRIBUTED IN THE U.K. AND EUROPE BY DAVID & CHARLES
Brunel House, Newton Abbot, Devon, TQ12 4PU, England
Tel: (+44) 1626 323200, Fax: (+44) 1626 323319
Email: postmaster@davidandcharles.co.uk

DISTRIBUTED IN AUSTRALIA BY CAPRICORN LINK
P.O. Box 704, S. Windsor NSW, 2756 Australia
Tel: (02) 4577-3555

Library of Congress Cataloging in Publication Data
Willenbrink, Mark and Mary
 Drawing for the Absolute Beginner / Mark and Mary Willenbrink. — 1st ed.
 p. cm
 Includes index.
 ISBN-13: 978-1-58180-789-9 (pb. : alk. paper)
 ISBN-10: 1-58180-789-9 (pb. : alk. paper)
 1. Drawing—Technique. I. Title.

ND2237 .B67 2001
571.42'24328—dc21 00-068694

Edited by Kelly Messerly
Designed by Guy Kelly
Production art by Lisa Holstein
Production coordinated by Matt Wagner

Metric Conversion Chart

To convert	to	multiply by
Inches	Centimeters	2.54
Centimeters	Inches	0.4
Feet	Centimeters	30.5
Centimeters	Feet	0.03
Yards	Meters	0.9
Meters	Yards	1.1
Sq. Inches	Sq. Centimeters	6.45
Sq. Centimeters	Sq. Inches	0.16
Sq. Feet	Sq. Meters	0.09
Sq. Meters	Sq. Feet	10.8
Sq. Yards	Sq. Meters	0.8
Sq. Meters	Sq. Yards	1.2
Pounds	Kilograms	0.45
Kilograms	Pounds	2.2
Ounces	Grams	28.3
Grams	Ounces	0.035

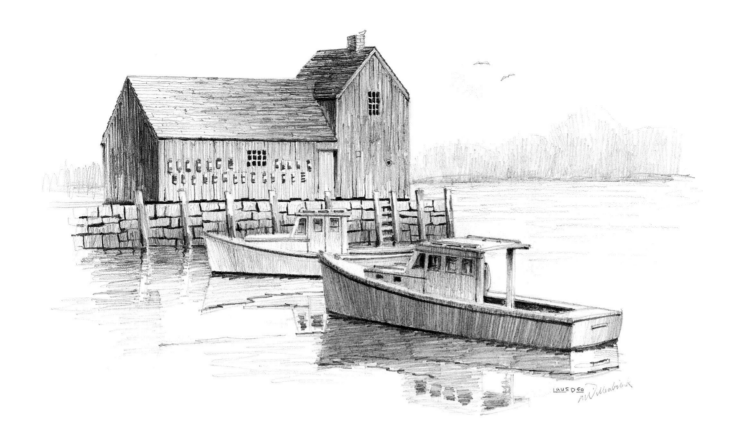

Acknowledgments

We would like to thank those behind the scenes at F+W Publications who have made this all possible: acquisitions editor, Pam Wissman; contracts manager, Julia Groh; editorial director, Jamie Markle; designer, Guy Kelly and production coordinator, Matt Wagner. We would also like to give a special thanks to Pam Wissman for her encouragement to write this book.

To our cherished editor, Kelly Messerly, we would like to give our heartfelt thanks. Your time, patience, talent and encouragement were wonderful! We could not have done this without you!

Thank you, Dorothy Frambes, Mike McGuire and Mary Helen Wallace for sharing your talents so they can be passed on to others.

We would like to thank our mothers, Clare Willenbrink and Grace Patton, who have been such an encouragement to us in our artistic pursuits. Also, thank you to our family and friends for your consistent support.

It is with great pride that we would like to acknowledge our three children for their patience and continuous support while we wrote this book. It is an honor to be your parents. Thank you, thank you, thank you!

It is our encouragement for each other and our unique insights that make this book special. It was fun to write together—which just proves that our marriage, like this book, is a work of art!

Lastly, we thank the Lord for His inspiration. We are all created in our Father's image to be creative, and with our creativity we praise Him.

Dedication

Laus Deo
Praise to God

We would like to dedicate this book to our fathers, Roy Willenbrink and Hugh (Bud) Patton, both of whom we love and miss greatly.

Contents

Introduction

Do you remember when you got out your crayons and drew pictures as a child? Now maybe you are proudly displaying your children's artwork on the refrigerator door. You love their pictures because you can see their unique expression in the art, even if it looks more like a Picasso than a Rembrandt. You were just as proud of your own artwork at one time but somewhere along the road of life you began to doubt your artistic abilities. Our belief is that everyone is an artist, and that includes you!

The skills necessary for drawing are not limited just to pencil and paper but can be used in other art forms. When you draw, you are interpreting what you observe from your own perspective. With the principles in this book, you will develop your observational skills, learn the proper tools to use, apply different techniques to your drawing and make use of some of the tricks professionals use every day.

You will learn more if you get out your drawing materials and become an active participant rather than if you just passively read through this book. The material is written to be used again and again. By doing the exercises more than once you will be able to witness the improvement of your artwork.

We hope you will regain that childlike passion for doing art and learning without critiquing yourself harshly. We won't make you hang it on the fridge, but we do suggest you save your artwork because it will show your progress and increase your confidence as you go.

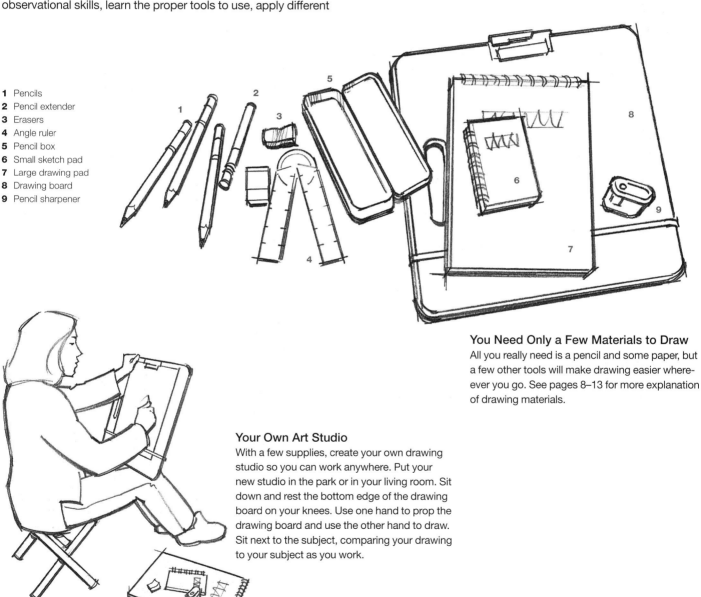

1 Pencils
2 Pencil extender
3 Erasers
4 Angle ruler
5 Pencil box
6 Small sketch pad
7 Large drawing pad
8 Drawing board
9 Pencil sharpener

You Need Only a Few Materials to Draw
All you really need is a pencil and some paper, but a few other tools will make drawing easier wherever you go. See pages 8–13 for more explanation of drawing materials.

Your Own Art Studio
With a few supplies, create your own drawing studio so you can work anywhere. Put your new studio in the park or in your living room. Sit down and rest the bottom edge of the drawing board on your knees. Use one hand to prop the drawing board and use the other hand to draw. Sit next to the subject, comparing your drawing to your subject as you work.

Pencils

Though one pencil may look just like any other, there are many different types of pencils to choose from. Each has different uses to achieve a wide range of results. One difference among pencils is the core, which may be made of *graphite*, *carbon* or *charcoal*. I especially like the graphite (commonly mislabeled lead) pencil because it can easily be erased, it comes in many degrees of firmness and it does not easily smear. Carbon and charcoal pencils provide rich, dark colors but they don't erase as well, smear easily and have a very soft feel. Black colored pencils don't smear, but they don't erase well and have a firm but waxy feel.

Pencil Hardness

Hardness is another important quality to consider when selecting pencils. Ratings, usually stamped on the pencils, range from H (hard) to B (soft), with F and HB in the middle. For the demos in this book, we will use 4H, HB and 4B graphite pencils. These will provide a range in hardness without requiring you to keep track of an overwhelming number of pencils. 8B pencils create nice darks, but they are so soft that they need to be continually sharpened.

Keep Your Pencil Choices Simple

4H, HB and 4B graphite pencils are used for the demonstrations in this book, but you may choose to use a different combination of pencil grades or a *mechanical pencil* for your own drawings apart from this book. If you are trying to duplicate the finished drawings in this book, make it easy on yourself and work with the same materials suggested, or you may end up frustrated, wondering why you achieved different results.

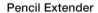

Woodless Pencils
Woodless pencils have only a thin coating over their thick cores. This is a novel idea, but woodless pencils are prone to breaking, especially when carried in a pocket! Use pencils with wood surrounding the core instead.

Runaway Pencils!
Use hex-shaped pencils instead of round pencils because round pencils roll and can get away from you.

Pencil Extender
To get more miles out of your pencils, use a pencil extender on the end of a pencil that has been shortened by use.

HARDER																**SOFTER**	
8H	7H	6H	5H	4H	3H	2H	H	F	HB	B	2B	3B	4B	5B	6B	7B	8B

Pencils Come in a Variety of Hardnesses

If you want to draw a thin line, you will need a sharp point on the tip of your pencil. You can sharpen your pencils in two ways: with a *pencil sharpener* or by hand, using a *craft knife* and a *sandpaper pad*.

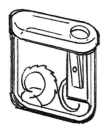

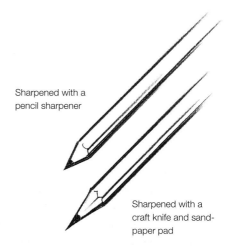

Sharpened with a pencil sharpener

Sharpened with a craft knife and sand-paper pad

Pencil Sharpeners Are the Simplest Way to Keep Pencils Sharp
A pencil sharpener is the quickest and easiest way to keep the tips of your pencils sharp.

A Craft Knife and Sandpaper Pad Reveal More of the Pencil's Core
For a controlled point that exposes more of the core, sharpen your pencil with a craft knife and sandpaper pad.

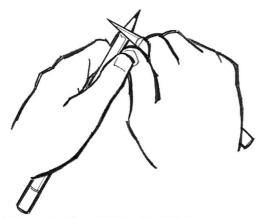

First Shape the Pencil With a Craft Knife
Grip the pencil in one hand, with the point away from you, and the craft knife in the other. Push the thumb holding the pencil against the thumb holding the knife to create leverage so the blade cuts into the pencil. Cut, then turn the pencil and repeat the process until you've worked the area into a point.

Identifying Your Pencils

To avoid having to search and squint to read the markings on the sides of your pencils, label the pencil ends with nail polish or colored tape. Place the nail polish or tape toward the top of the pencil, but avoid covering the rating stamp or placing it where the pencil extender would cover it.

Then Sharpen the Core With a Sandpaper Pad
Sand the core back and forth on the sanding pad for a sharp point.

Paper and Drawing Board

Papers for sketching and drawing vary in size, weight, surface texture (usually referred to as *tooth*) and content. They may also be categorized as either sketch or drawing paper. When choosing drawing paper, always choose an *acid-free paper,* or the paper may yellow over time. *Sketch paper*, as the name implies, is for sketching and usually has a *paper weight* of 50 to 70 lbs. (105gsm to 150gsm). *Drawing paper*, which is for more finished art, usually comes in 90-lb. (190gsm) weight. A small 6" × 4" (15cm × 10cm) pocket sketch *pad* is great for quick studies and ideas, while larger sketch pads are obviously needed for bigger

sketches. Any drawing you begin may be completed as a keeper, so you may prefer to begin all your drawings using an 11" × 14" (28cm × 36cm) medium-tooth, acid-free, 90-lb. (190gsm) drawing paper.

The lights and darks in a drawing are achieved by varying the amount of pressure applied to the pencil. Because of this, it is necessary to have a hard surface beneath the paper, ideally a *drawing board*. It offers a smooth, solid surface without surprise ruts or nicks, and it won't bend or give with pressure the way the cardboard back of a drawing pad can.

Sketching and Drawing Paper
Use both a small sketch pad and a larger drawing pad. Tear out the individual drawing pad sheets and use them on a drawing board.

Drawing Boards Provide a Hard, Smooth Surface
Drawing boards can be bought with a clip attached to one end and a rubber band on the other to hold a sheet of paper in place.

Tracing Paper and Masking Tape

Use *tracing paper* to make a more refined sketch. Put the previous sketch under the top sheet of tracing paper. Use masking tape to secure the sheets of paper to each other, then carefully trace the desired elements of the image onto the tracing paper.

Erasers

Erasers are the sort of thing to have with the idea that you will use them only sparingly. Each time you use an eraser, you risk smearing the drawing or damaging the paper.

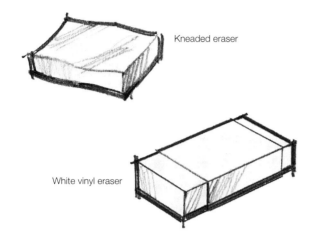

Kneaded eraser

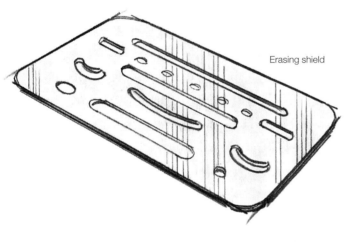

White vinyl eraser

Erasing shield

Kneaded Eraser

The first eraser you get should be a *kneaded eraser*. These soft, putty-like erasers are very gentle to the paper's surface and leave few, if any, crumbs. To erase, first try pressing the eraser to the paper's surface; this is less damaging to the paper than rubbing the eraser back and forth.

White Vinyl Eraser

Use a *white vinyl eraser* to remove hard-to-erase pencil lines. White vinyl erasers are more abrasive than kneaded erasers but will not stain the paper, as some colored erasers often do. White vinyl erasers leave behind strings rather than crumbs, making cleanup easy.

Erasing Shield

Made of thin metal, an *erasing shield* masks the areas that are not to be erased. To use it, with one hand firmly hold the shield down over the area not to be disturbed and, with your other hand, carefully erase over top of the shield.

Avoid Using the Eraser at the End of Your Pencil

Never use the eraser at the end of a pencil. It may smear pencil lines and stain the paper.

In addition to the basic supplies, there are other tools that will help make your drawing experience easier and more enjoyable.

Straightedge

Using a *straightedge* will give you sharp, accurate lines when your subject is technical and requires precision. The precision from a straightedge would look awkward in a sketchy drawing, though. If you want straightedge accuracy without the tightness, use the straightedge during the sketching stage with a light pencil line, then draw over those lines more heavily freehand in the drawing stage.

Triangle

Because it is larger than a ruler and has more surface area to grip, a *triangle* can be easy to use for drawing straight lines.

T-Square

Using a triangle with a *T-square* hooked to the side edge of your board or drawing pad will help you draw more precise vertical, horizontal and diagonal lines. This method is best used for drawing technical subjects such as buildings in linear perspective (see pages 32–38).

Angle Ruler

An *angle ruler* works like a ruler, but it can pivot to measure angles and can fold small enough to fit in a pencil box. See page 30 for instructions on using this tool to draw angles.

Dividers

Dividers are used to observe and duplicate proportions from a photo or sketch. See page 29 for instructions on using standard dividers.

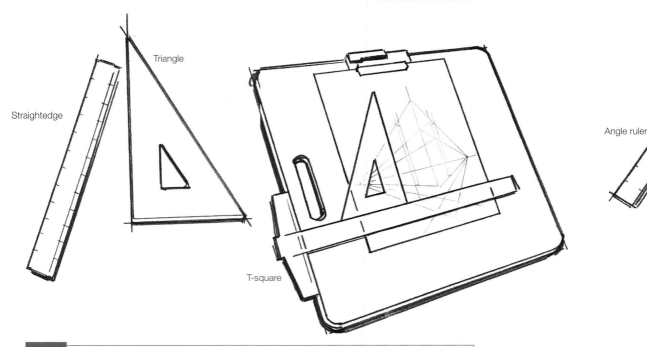

Triangle

Straightedge

T-square

Angle ruler

Must-Have Materials

- 4H, HB and 4B graphite pencils
- Pencil sharpener
- Sketch pad
- 11" × 14" (28cm × 26cm) medium-tooth drawing paper
- Drawing board
- Kneaded eraser
- White vinyl eraser

Optional, But Not to Be Overlooked
- Straightedge, triangle or angle ruler
- Light box

- Dividers, proportional dividers or sewing gauge
- Small mirror
- Erasing shield
- Pencil extender
- Craft knife
- Sandpaper pad
- T-square
- Fixative
- Tracing paper
- Masking tape

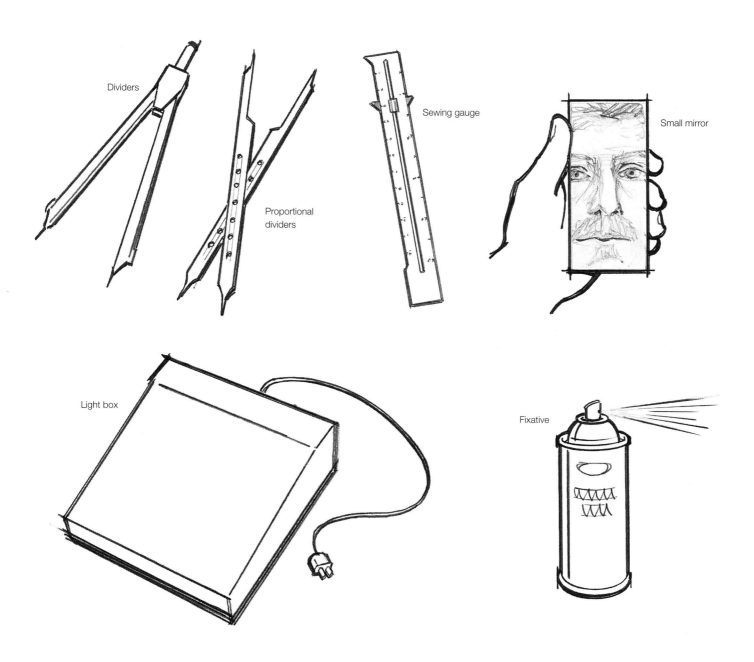

Dividers

Proportional dividers

Sewing gauge

Small mirror

Light box

Fixative

Proportional Dividers

Proportional dividers are used to proportionally enlarge or reduce a image. (See page 29 for additional instruction.)

Sewing Gage

A *sewing gauge* is an inexpensive tool that can be used to measure the proportions of a still life, three-dimensional subject matter, or when working from flat reference materials such as photographs.

Light Box

A *light box* allows you to work from a structural drawing without having to sketch guidelines directly on your drawing paper. This process is explained in more detail on page 24.

Small Mirror

Use a small mirror for self-portraits and for observing facial features. It is also handy for examining your artwork in reverse form. Looking at a drawing in reverse will allow you to see the composition through fresh eyes.

Fixative

Fixative is a spray applied to pencil drawings to prevent the artwork from smudging. It's used mostly for carbon or charcoal drawings, which tend to be powdery. For the demos in this book, fixative isn't necessary because you'll be drawing with graphite. Graphite is not likely to smear if the drawings are stored loosely, one on top of the other.

1 Sketching & **Drawing**

Sketching and *drawing* are two different things. A *sketch* is a work in progress. You may sketch to observe your subject matter or to resolve questions regarding a drawing you are working on. A sketch may help you understand the values of a subject, or gain more understanding of the subject's structure, proportions and placement of its compositional elements. Sketches like these may progress toward a more finished drawing. On the other hand, (no pun intended!) *drawing* is an activity that is begun with the intention of producing a finished piece of art.

With these definitions in mind, recognize that there are times to begin a drawing with a sketch and there are times to begin a sketch without any intention of refining it into a finished drawing. As a beginner, if you are trying to do more drawings than sketches, then you may be putting too much pressure on yourself. Loosen up and enjoy learning four different approaches to sketching and drawing: structural line sketching, value sketching, black-and-white sketching and contour sketching.

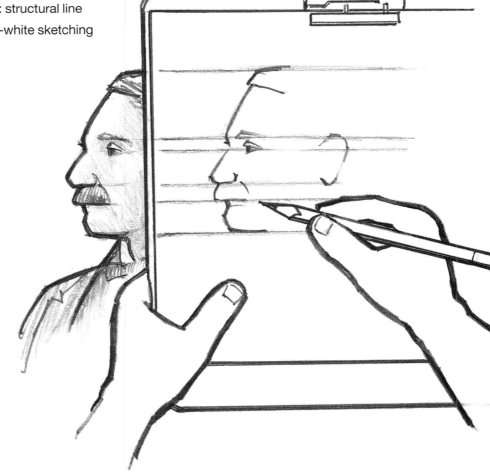

Let the Lines Guide You
Line up your drawing board and paper with your subject and lightly sketch horizontal lines. These will guide you as you place your subject's features. Grab a friend and try it yourself!

Holding the Pencil

There are different ways to hold a pencil, depending on what type of strokes and lines you want to achieve. You may start out with loose, sketchy lines and progress to tighter, more controlled lines and shorter strokes. Here are some common hand grips you can try as you sketch and draw. You may find something else that works better for you. You will find that pressure and grip affects the line results of your drawings. Generally, the more pressure you apply, the darker your line will be.

Create Thick, Loose Lines

For thick, loose lines, avoid using the point of the pencil. Instead, grip the pencil with your thumb and fingertip so that the pencil lead lies flat against the paper. Your fingertips should be either just above the paper surface or gently resting on it. This may smear your previous pencil lines, so be careful. You will use your entire arm to draw these wide lines.

Create Thick, Tight Lines

Apply more pressure to the point of the pencil by moving your index finger closer to the tip. Your fingertips may rest on the paper, though it isn't necessary that they do so for this stroke to be successful.

Create Thin, Controlled Lines

For lines like these, grip the pencil as in a handwriting position, with the pencil resting between your thumb, middle and index fingers. Your hand rests gently on the paper. For very thin lines, the pencil tip needs to come to a sharp point.

Create Long, Arcing Lines

This grip is similar to the handwriting position, except you hold the pencil out at length. Use this grip to achieve wide, straight and arced lines. Let your hand rest gently on the paper.

Using a Frisket

A piece of paper can be used as a *frisket* to make an even edge for a set of pencil lines. This is also a great technique to use if you want to create a clean margin for your drawing. This method also works well for backgrounds.

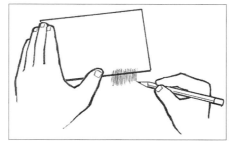

Cover the Drawing

Place a piece of scrap or copier paper over your drawing. Start the line strokes on the scrap paper and continue onto the drawing paper.

Lift the Frisket

Lift your frisket away. The pencil lines should look as if they start from one invisible line.

Structural Sketches

A *structual sketch* is the basic linework in which values and details are built upon. They are a great way to observe your subject, and are often used as a basis for a more finished drawing. A structural sketch is also an excellent way to loosen up before doing another type of sketch or drawing.

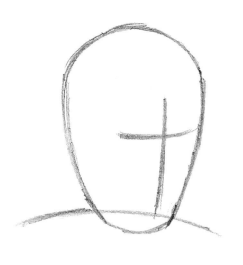
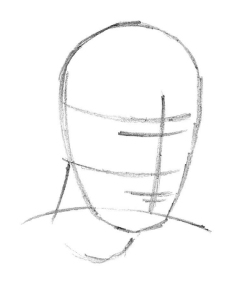
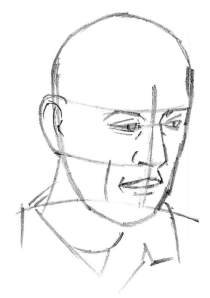

Focus on the Basic Structure
A structural sketch will help you observe and understand the underlying structure of the subject. Here you will focus on the placement and proportions of the elements rather than on light or shadows (see page 18).

Structural Sketch of a Coffee Cup

A structural sketch helps you see how a subject is constructed. Look for basic shapes such as squares, rectangles and circles. Now ask yourself how they relate to one another. Before you pick up your pencil to sketch your coffee cup, take a minute to study your subject.

Must-Have Materials

4H graphite pencil
Drawing paper
Kneaded eraser
Straightedge (optional for the first step, absolutely prohibited for the rest of the steps)

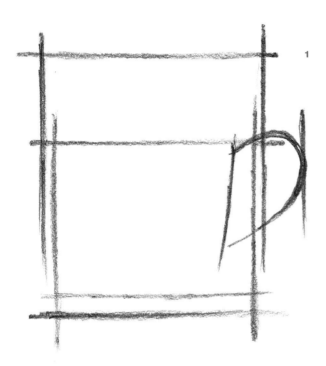

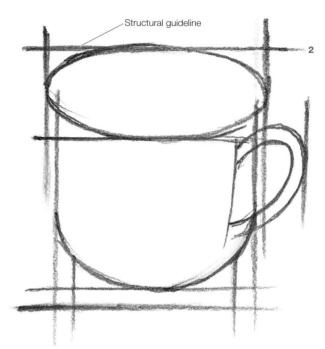

Structural guideline

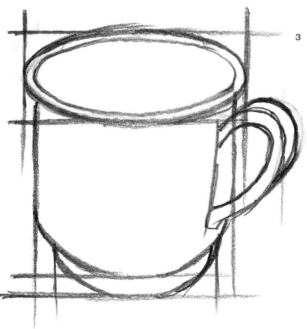

Sketch the Basic Form and Structures
Use a 4H pencil to sketch the outer forms of the mug and the most relevant structural guidelines, such as those that will indicate the placement of the rim, the bottom of the cup and the handle.

Add More Structural Lines
Sketch the rim of the cup and the handle. Use the lines you drew in step one to help you add these additonal lines. Look for points where elements line up such as the rim of the cup and handle.

Add Detail Lines to Finish
Add details such as the inner lines of the rim and handle. Erase any unnecessary guidelines with a kneaded eraser.

Value Sketches

Values are the degrees of lights and darks in a drawing or painting. A *value sketch* is used to observe a subject without much regard for structural or proportional accuracy. Here you focus on the lights and darks of your subject. One way to visually separate the structural lines from the values is to squint at your subject.

This blurs the structural lines and makes the lights and darks more noticeable. For a finished drawing that employs values, it's a good idea to do a structural sketch first to make sure the elements of your subject are in the right places. See page 24 for more explanation of combining drawing approaches.

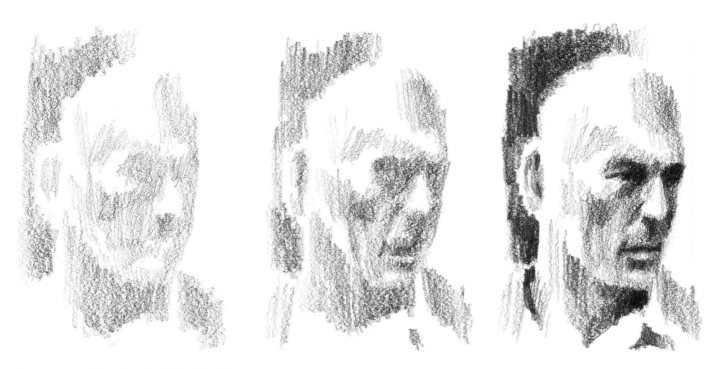

Use Layers of Shading for Value Sketches
Begin a value sketch by first locating the areas of highlights, which will be left white. Then lightly shade the areas of overall values. The next step is to add more layers of shading for the middle values. Finally, add the darkest shading.

Using an Erasing Shield

If you want to erase in a specific area of your drawing, use an erasing shield. Place the erasing shield over the region that is not to be erased. Gently begin erasing with a kneaded eraser. Use a white vinyl eraser if the kneaded eraser doesn't fully erase the first time.

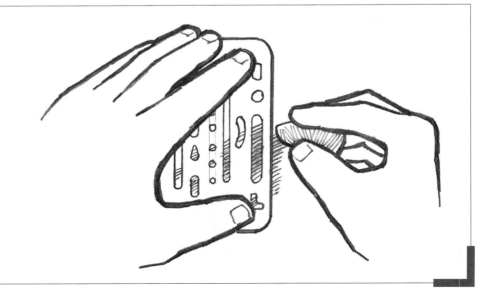

Value Sketch of a Coffee Cup

MINI DEMONSTRATION

In this exercise you will be focusing on values instead of lines. The idea of a value sketch is to define form through light and shadow instead of lines, so use shading to give your coffee cup form. Remember, this is not intended to be a finished drawing, so relax and enjoy the process.

1 Sketch the Lighter Values
Use a 4B pencil to sketch the lighter values, keeping the lightest ones the white of the paper. Use pencil strokes that feel comfortable for you. They may be vertical, horizontal or even scribbles.

2 Sketch the Middle Values
Continue adding layers for the middle values, gradually giving form to the sketch.

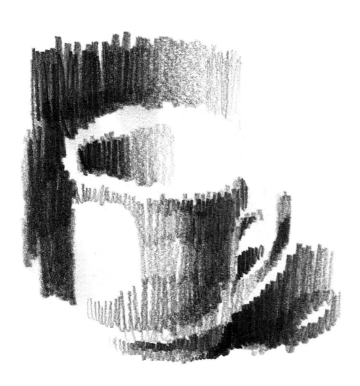

3 Sketch the Dark Values
Finish by adding more layers for the darkest values. Use a kneaded eraser to lighten some areas if you think they need it.

Black-and-White Sketches

Black-and-white sketches are like value sketches, except that you focus on the contrasting blacks and whites and ignore the middle values. Your softest 4B pencil will work, but charcoal and carbon pencils work especially well for this because of their rich, dark qualities. Also called *chiaroscuro* sketching, this type of sketch is a good exercise for understanding what makes images visually identifiable with the most basic of values, black and white.

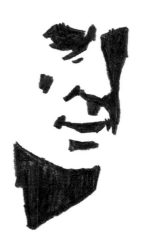
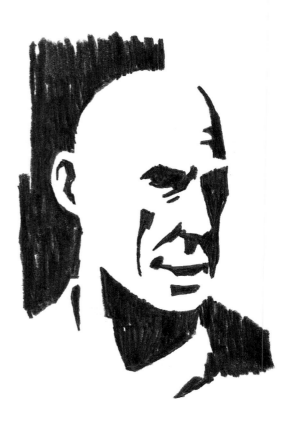

No Outlines or Middle Values Allowed
No matter what part of the subject you're drawing, use only black and white forms to define it for a *Chiarosuro* drawing.

Avoid Smudges

As you are drawing, your hand glides over the paper surface and can smear the pencil lines. One solution to this is to use a *slip sheet*, which is a sheet of paper placed between your hand and the drawing surface. This way your hand does not rest directly on the drawing.

Chiaroscuro Coffee Cup

MINI DEMONSTRATION

No, it's not a fancy type of coffee, it's a black-and-white sketch of a coffee cup! This is like taking a value sketch to the extreme; no outlines and no middle values will be used to interpret the subject. Use this method to examine a subject's most basic lights and darks.

Remember, this is just a study. Like a sketch, this is not intended to look like a finished drawing.

Must-Have Materials

Anything from a 4B to 8B graphite, carbon or charcoal pencil
Drawing paper
Kneaded eraser

1 Start With the Most Obvious Darks
With a soft-lead pencil, sketch the most noticeable darks of the subject. In this case, the interior of the mug, along the rim, and down the right on the outside of the mug are the darkest areas. Keep your pencil strokes close together so areas will look black.

2 Add More Darks
Continue adding darks, using them to define the image.

3 Add a Background
Finish adding darks to complete the mug. Add a background and some shadows to further define the image.

Contour Sketches

This type of sketch is also called a *continuous line sketch* because you draw with one continuous line, drawing outlines and defining value areas. Don't worry about accuracy. This is a fun exercise for loosening up before you draw, and it will sharpen your observation skills. Add more of a challenge by blocking your view of the sketch in progress, letting your hand guess at what the pencil line looks like on the paper. This is called *blind contour sketching*.

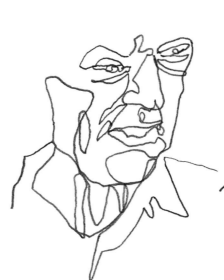
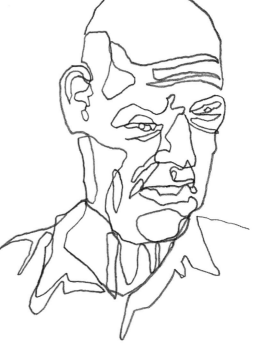

Continuous Line Sketch
Once you start moving your pencil, don't lift it until the sketch is done.

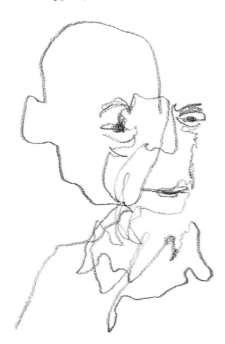

Blind Contour Sketch
This sketch was done by observing the subject without looking at the drawing paper. Block your view of the sketch with a piece of cardboard until you're finished.

Blind Contour Sketches Help You Understand Your Subject
No one expects contour sketches to be identifiable. As Mary worked through this sketch, she gained a real understanding of the contours of her coffee cup.

Contour Sketch of a Coffee Cup

MINI DEMONSTRATION

This sketch is done by placing the pencil onto the paper and not lifting it until the sketch is finished. Look for lines and shapes. Follow the contours that define the subject and the shadows around it. Doing a contour sketch is truly an exercise in putting observation into practice!

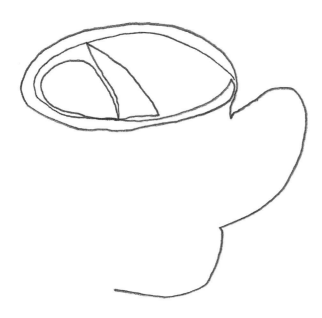

1 Start Moving the Pencil
Put an HB pencil to the paper and start moving it, following the contours of the subject without lifting the pencil from the paper.

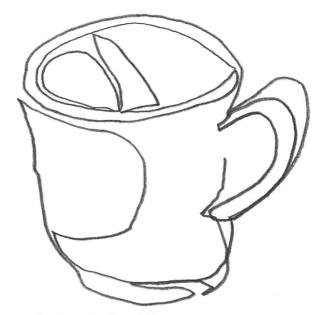

2 Continue the Pencil Movement
Keep moving the pencil so that the sketch is formed with a single line.

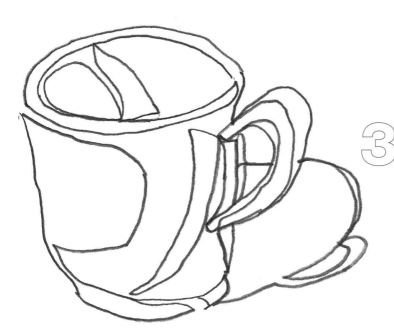

3 Finish Up
Keep moving the pencil until the sketch is complete.

Combining Approaches

We've explored four different approaches to sketching and drawing. If you tried the value, black-and-white or contour sketch demos, you might be thinking your art didn't turn out anything like you expected. Do not be discouraged and don't give up! You are already growing in your observation skills.

You can combine some of the different approaches to achieve a more finished drawing. For instance, start with a structural line sketch and then add values. During the structural sketch stage, you should look for the basic shapes (see page 27) and proportions (see pages 28–29) so you can be confident of their placement before you add the values.

A light box is a device that allows you to see the structural lines for a drawing without having to draw them on the artwork itself. First, create a structural sketch of your subject. Place the structural sketch on the light box, then tape a piece of drawing paper to the structural line sketch. The image will be visible through the drawing paper to provide a foundation for your value, black-and-white and contour drawings.

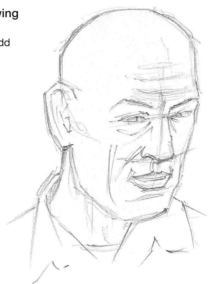
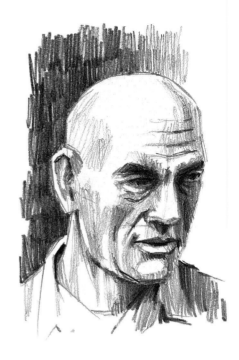

Combine Approaches for a Finished Drawing
Work out proportions with a structural sketch and placement of the elements in your composition. Add value changes to define form and shadow.

A Light Box Makes Combining Drawing Approaches Easy
Do a structural sketch of your subject, erase obsolete guide lines and add detail lines defining the form and shadows. Use this sketch as the basis for a value sketch, black-and-white sketch or contour sketch. Place the sketch on a light box and then place your drawing paper on top of the sketch. Turn on the light box so the image of the sketch will be visible through the drawing paper. This will provide a framework for your subject so you don't have to sketch the structural guidelines onto the drawing paper.

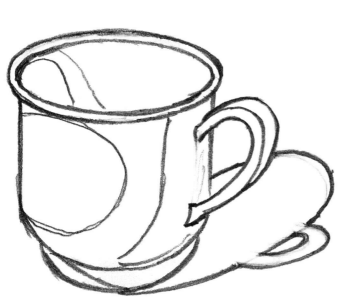

Structural Line Sketch
These lines indicate highlights and shadows as well as the structure of the subject. To use other drawing approaches, erase any obsolete markings.

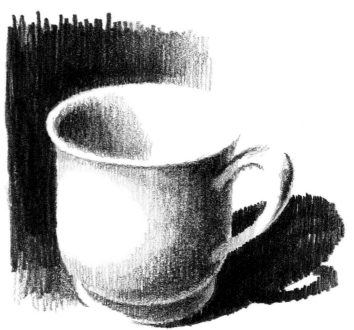

Value Drawing Using the
Structural Line Sketch and Light Box
A light box was used to backlight the structural sketch as a guide for this value drawing.

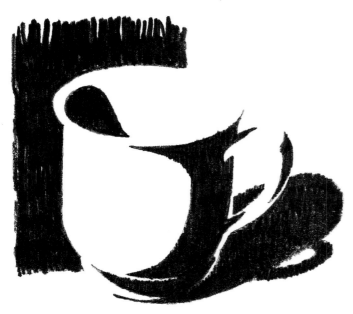

Black-and-White Drawing *(Chiaroscuro)*
Using the Structural Sketch and Light Box
A light box was used to backlight the structural sketch as a guide for this black-and-white drawing.

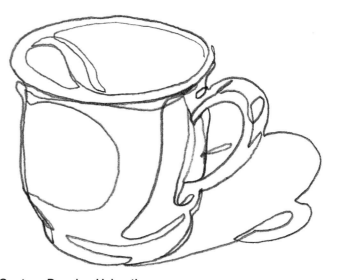

Contour Drawing Using the
Structural Sketch and Light Box
A light box was used to backlight the structural sketch as a guide for this contour drawing.

2 Principles of **Good Drawing**

Good drawing does not come just from having a skilled or trained hand, but also from your ability to observe your subject matter. In fact, one of the things we love most about art is being able to see how each artist interprets a subject. What is it that gives someone the ability to draw well? It is a matter of learning basic principles, applying them consistently and training the eye to observe the subject. *Observing* invovles noticing the basic shapes, proportions and values of objects rather than thinking of them as "buildings," "trees" or "people." Once you have an understanding of the principles and have trained yourself to observe, it is then only a matter of telling your hand to draw what your eye sees, not what your mind thinks the subject should look like.

Using Basic Shapes

Before you pick up a pencil to begin drawing, take time to observe your subject matter. Look for the basic shapes, then sketch them lightly on your drawing paper, working out the correct proportions of those shapes and determining where each should be in relation to one another. If you have questions about the composition, do a few quick *thumbnail sketches* at this point. Once you decide where to place the major elements of your composition, take your sketch to the next step, adding structural details. Finally, add the values. This method of drawing will help ensure that the results will be proportionally correct.

Must-Have Materials
HB graphite pencil
Drawing paper
Kneaded eraser

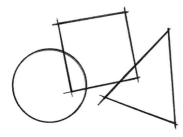

1 Look for the Basic Shapes
Look for circles, squares, triangles, ovals and rectangles in your subject before you sketch.

2 Sketch the Basic Structure
Start with the basic shapes and use them to work out proportions (see page 28) and composition (see page 86).

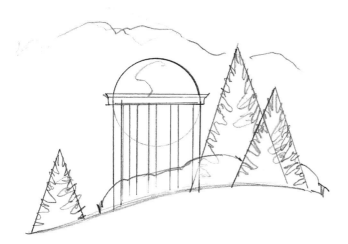

3 Add Details to the Structural Sketch
Add the details including the columns and trim to the building, define the shape of the trees and add a row of shrubs in front of the building.

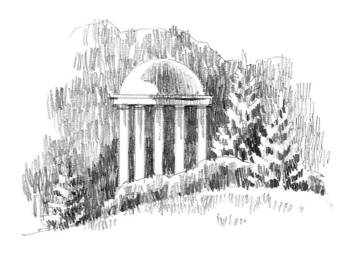

4 Add the Values
Add values over the lines to give the scene depth and definition, and to make it look more realistic.

Gauging proportions is as simple as making sure that the *width* and *height* of the objects in your drawing are proportionally similar to those in your reference. Believable art starts with correct proportions, so learning how to gauge proportions accurately will be invaluable. You don't need to know the actual inches or centimeters; instead, measure the *relative* sizes of the elements to achieve an accurate representation of your subject.

There are many tools available for gauging proportions, from a simple pencil to tools made specifically for measuring, such as sewing gauges or dividers. Dividers, both standard and

Gauging Proportions With a Pencil

Gauging Proportions can be done by "measuring" each part of the subject with a pencil. Use the top of your thumb to make the distance from the end of the pencil. Now compare this measurement with those of other parts of the image. In this example, the teapot's height is equal to its width.

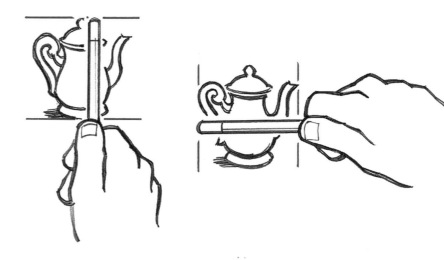

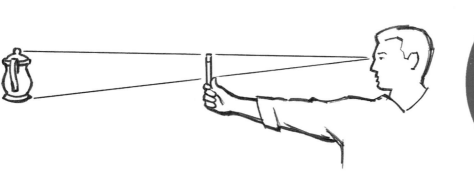

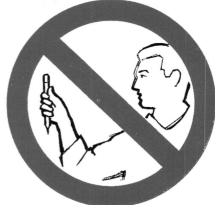

Lock in Accurate Proportions

To correctly gauge proportions in this manner, lock your arm straight in front of you, holding the pencil straight up. Look at the pencil and the subject you're measuring through one eye. A bent arm may result in inaccurate measurements because you may bend your arm at different angles from one measurement to another.

proportional, are used to gauge proportions of two-dimensional reference materials, such as photographs, rather than of three-dimensional objects, such as those in a still-life setup. Proportional dividers enable you to enlarge or reduce by measuring the reference with one end of the tool and then using the other end to determine the size of the image in your drawing.

Proportioning can be done loosely for a quick sketch or more precisely for a finished drawing. The subject also influences how accurate the drawing needs to be. You may be less concerned about the proportions of a tree than you are about the proportions of an automobile.

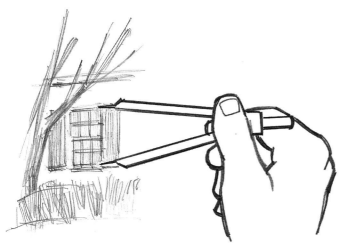

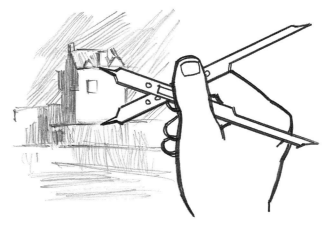

Using Standard Dividers

Measure the subject in your reference with the dividers and transfer the length to your surface. You can only measure a one-to-one ratio with standard dividers. If you wanted to enlarge this window to twice its size, you would have to double the divider's measurement.

Using Proportional Dividers

Proportional dividers are used not only to compare proportions but also to enlarge or reduce. Measure the subject in your reference with one end of the dividers, then use the other end to mark the measurement for your drawing. The notches in the center of the dividers let you determine just how much you want to enlarge or reduce the size of the image.

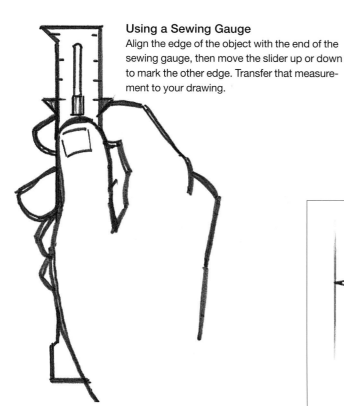

Using a Sewing Gauge

Align the edge of the object with the end of the sewing gauge, then move the slider up or down to mark the other edge. Transfer that measurement to your drawing.

Get It Straight

Straight lines can be drawn using a straightedge or ruler. Another method is to place the side of the hand holding your pencil against the edge of your drawing surface, then glide your hand along the edge.

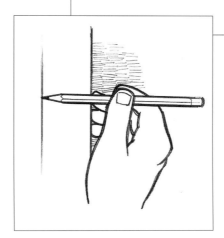

Measuring Angles

Measuring angles sounds technical, but drawing angles mostly involves observation. If you want to take the guesswork out of drawing angles, use an angle ruler. Correct angles will make your drawings more successful.

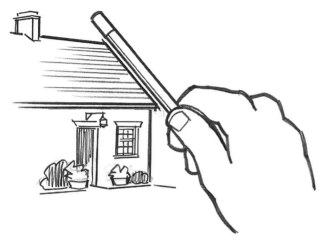

Duplicate the Angle
First, duplicate the angle of the subject by aligning a pencil with it.

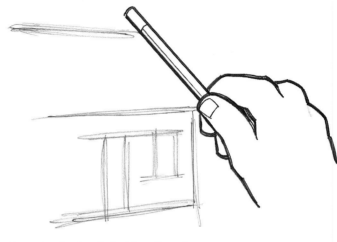

Transfer the Angle to Your Drawing
Keeping the pencil at the same angle, hold it over the drawing and adjust the sketch as needed.

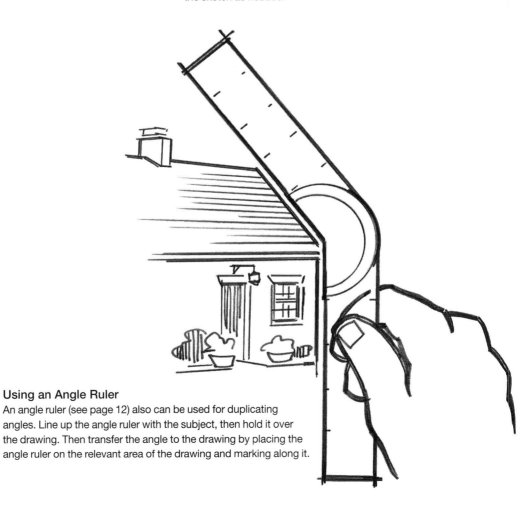

Using an Angle Ruler
An angle ruler (see page 12) also can be used for duplicating angles. Line up the angle ruler with the subject, then hold it over the drawing. Then transfer the angle to the drawing by placing the angle ruler on the relevant area of the drawing and marking along it.

Working From Reference Materials

Images from books, magazines, greeting cards or the Internet that allow you to observe a particular subject are called *reference materials*. It is good to practice observing actual subjects such as the birds in your backyard. Firsthand observation will help you to capture the essence and nature of your subject. The problem with observing from life is that the subject, especially an animal, may not stay still for you. Moreover, the lighting and colors will constantly change. A still life, in which you set up your subject matter with a consistent light source, is another option. You can sit down and take your time observing your subject at your leisure—be sure to warn your family that the fruit bowl is being used for study, or your reference may be eaten by mistake!

How to Approach a Challenging Drawing

Some subjects may seem so daunting, you may not know where to begin. Even finding the basic shapes, which is the best place to begin, may be hard. The following method may help.

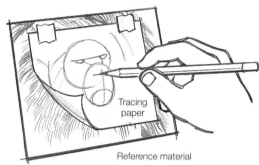

Trace the Basic Shapes
Lay a piece of tracing paper over your reference and trace the basic shapes of the image.

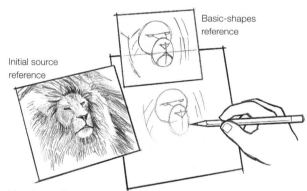

Use Your Tracing as a Reference
Use the tracing as another reference to determine the placement of the shapes and their proportions as you begin the drawing.

Reference Materials
Observation of a subject can be enhanced with reference material. Start a reference file by categorizing photos and magazine pictures in an accordion folder.

Understanding Linear Perspective

Perspective is what gives the illusion of depth to a picture. It affects almost everything we see, if only in subtle ways, which is why it is important to have an understanding of how perspective works. Artists employ two types of perspective: *linear* and *atmospheric* (also called *aerial*). Linear perspective involves the use of converging lines and the manipulation of the size and placement of elements within a composition to create the illusion of depth and distance. Atmospheric perspective, which will be explained in more detail on page 41, relies not on lines but on variations in value and detail to achieve similar effects.

Horizon Line

The first step in using linear perspective is to establish a *horizon line* where the land or water meets the sky. The placement of the horizon influences the viewer's perception of a scene and determines where its sight lines should converge. Even when the horizon line is not actually visible, its location must be clear or the perspective of the scene may not be correct (see page 39).

Vanishing Points

Vanishing points occur where parallel lines appear to converge, usually on the horizon. For example, when you look down a train track, the rails seem to converge in the distance. The place where the rails appear to meet is the vanishing point. A single drawing may contain several vanishing points—or none at all—depending on the location of elements within a scene and the *vantage point* of the viewer.

Vantage Point

The best way to describe the vantage point is to say that it is the point from which the viewer observes a scene. In a drawing, the relationship between the location of subject elements (such as trees and buildings) and the horizon line will determine the *eye level* of the vantage point. In addition, the vantage point can influence the mood of a scene (see page 33).

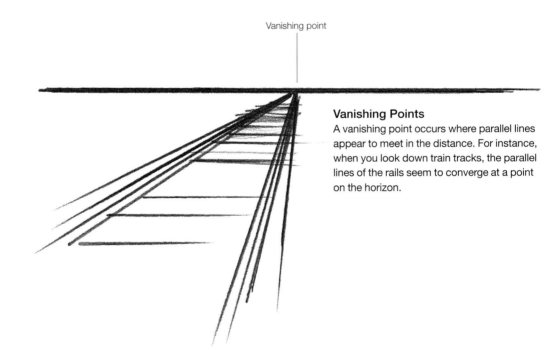

Vanishing point

Vanishing Points
A vanishing point occurs where parallel lines appear to meet in the distance. For instance, when you look down train tracks, the parallel lines of the rails seem to converge at a point on the horizon.

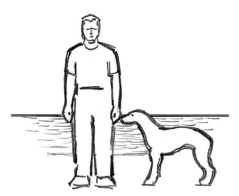

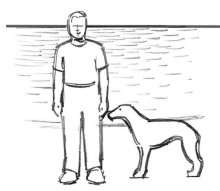

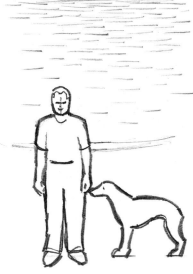

Dog's Eye Level
Placing the horizon low makes the vantage point seem low. In this example, the vantage point is at the dog's eye level. Notice that the horizon line goes through the eye of the dog.

Man's Eye Level
Placing the horizon at the same level as the eyes of the man in the scene puts the vantage point also at the man's eye level. In this example, the horizon line runs through the man's eyes.

Overhead View
With the horizon placed well above the man and dog, the vantage point is also very high. This creates the feeling that the viewer is looking down on both of them.

Low Horizon, Low Vantage Point
With the horizon placed low, the subject may look taller and more massive than normal.

High Horizon, High Vantage Point
A high horizon can give an unnatural feel to a subject that is normally viewed from eye level. Instead, bring the horizon line down to a more natural vantage point.

Vantage Point Can Influence Mood
The placement of the horizon can influence the mood of a scene by creating a variety of sensations in the viewer. Placing the horizon unnaturally low will make the viewer feel as if he were looking up at the subject from a very low vantage point. Placing the horizon unnaturally high will make the viewer feel as if he were looking down on the subject from a great height.

One-Point Perspective

One-point perspective is a simple form of linear perspective with only one vanishing point. Remember to always draw the horizon line first, then determine the placement of the vanishing point on the horizon, which should not be far from the center of the scene. First draw the horizon line, then determine the placement of your two vanishing points on either side of the paper on the horizon line. As you work out the perspective of the elements in the scene, extend the parallel lines either up or down toward the vanishing point, depending on the vantage point you want to create for the viewer.

Let's Get Technical

Use a T-square or triangle with your drawing board. These tools will make technical and perspective drawings easier to do and more accurate.

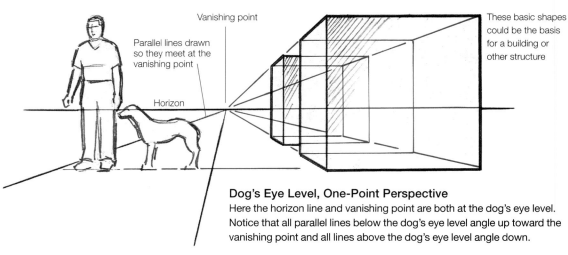

Vanishing point

Parallel lines drawn so they meet at the vanishing point

Horizon

These basic shapes could be the basis for a building or other structure

Dog's Eye Level, One-Point Perspective

Here the horizon line and vanishing point are both at the dog's eye level. Notice that all parallel lines below the dog's eye level angle up toward the vanishing point and all lines above the dog's eye level angle down.

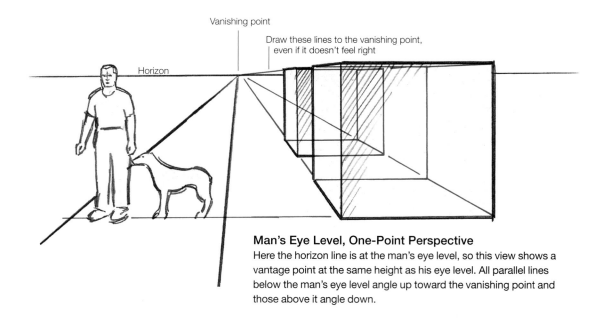

Vanishing point

Draw these lines to the vanishing point, even if it doesn't feel right

Horizon

Man's Eye Level, One-Point Perspective

Here the horizon line is at the man's eye level, so this view shows a vantage point at the same height as his eye level. All parallel lines below the man's eye level angle up toward the vanishing point and those above it angle down.

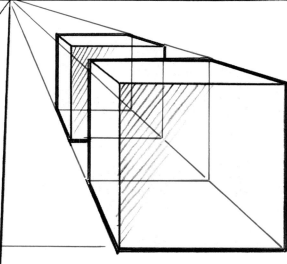

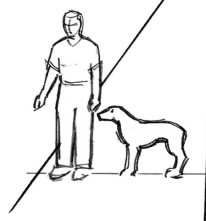

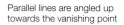

Vanishing point

Horizon

Parallel lines are angled up
towards the vanishing point

Overhead View, One-Point Perspective
In this view, the horizon is above both the man and the dog. The vantage point is somewhere
above the man and the dog creating the feeling that the viewer is looking down on the scene.
All parallel lines angle up to converge at the vanishing point.

Principles of Perspective

There are three important principles to keep in mind when you
render linear perspective:

- *Depth is expressed by size.* Similar objects will appear
 bigger if they are positioned closer to the viewer than if
 they are placed farther away.
- *Depth is expressed by obscurity.* Objects closer to
 the viewer may hide from view, cover up or cancel out
 objects that are farther in the distance.
- *Depth is expressed by convergence.* Elements that are
 parallel to each other will appear to converge in the
 distance. The point of convergence is called the vanish-
 ing point. A scene with linear perspective may have an
 unlimited number of vanishing points, or none at all.

Two-Point Perspective

Two-point perspective employs the same principles as one-point perspective but with an additional vanishing point. Two-point perspective can give a scene more depth than one-point perspective. The first object you draw will help you determine the relative sizes of any other objects in the composition.

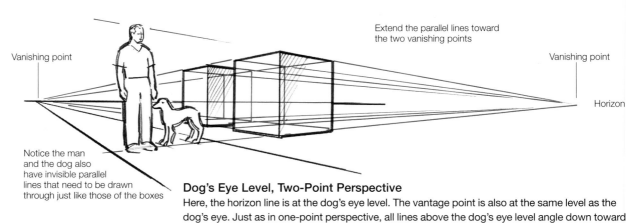

Dog's Eye Level, Two-Point Perspective

Here, the horizon line is at the dog's eye level. The vantage point is also at the same level as the dog's eye. Just as in one-point perspective, all lines above the dog's eye level angle down toward the vanishing points and all lines below the dog's eye level angle up toward the vanishing points.

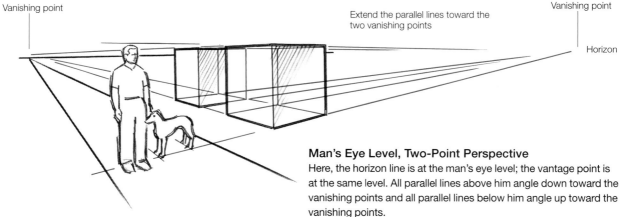

Man's Eye Level, Two-Point Perspective

Here, the horizon line is at the man's eye level; the vantage point is at the same level. All parallel lines above him angle down toward the vanishing points and all parallel lines below him angle up toward the vanishing points.

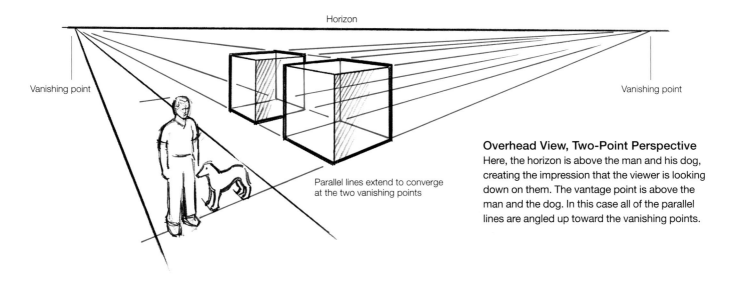

Overhead View, Two-Point Perspective
Here, the horizon is above the man and his dog, creating the impression that the viewer is looking down on them. The vantage point is above the man and the dog. In this case all of the parallel lines are angled up toward the vanishing points.

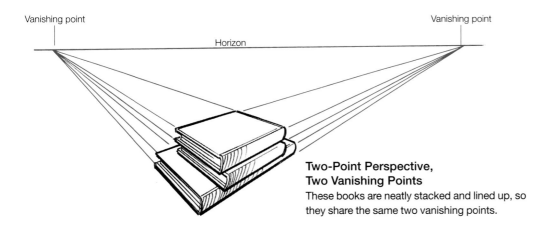

Two-Point Perspective, Two Vanishing Points
These books are neatly stacked and lined up, so they share the same two vanishing points.

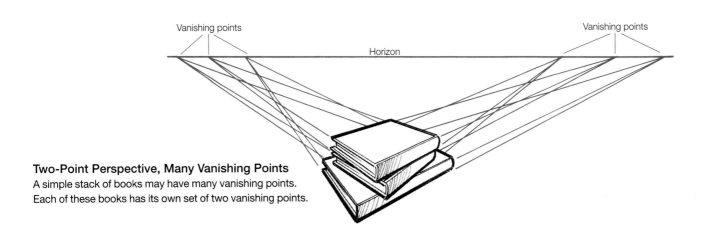

Two-Point Perspective, Many Vanishing Points
A simple stack of books may have many vanishing points. Each of these books has its own set of two vanishing points.

Three-Point Perspective

Linear perspective may include many vanishing points, as shown by the staggered books on page 37. When you add more vanishing points to a scene, you also add drama and complexity to your composition. If you take a vanishing point and move it high above or far below the horizon, you will create *three-point perspective*.

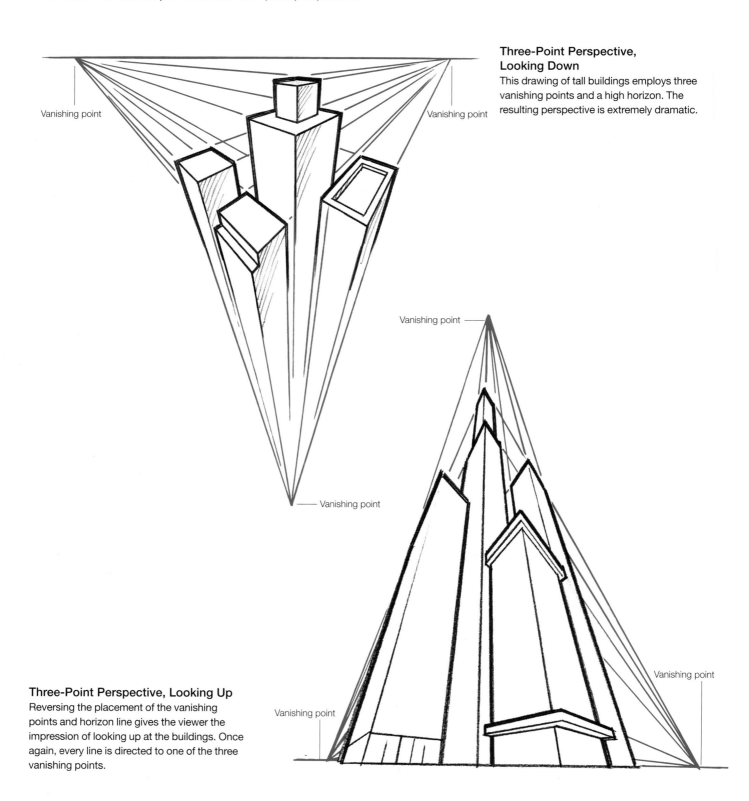

Three-Point Perspective, Looking Down
This drawing of tall buildings employs three vanishing points and a high horizon. The resulting perspective is extremely dramatic.

Vanishing point

Vanishing point

Vanishing point

Vanishing point

Vanishing point

Vanishing point

Vanishing point

Three-Point Perspective, Looking Up
Reversing the placement of the vanishing points and horizon line gives the viewer the impression of looking up at the buildings. Once again, every line is directed to one of the three vanishing points.

Hidden Horizons and Vanishing Points

Applying the principles of perspective to all objects in a scene is important, even though horizons and vanishing points aren't always noticeable. They may be hidden behind other elements in the composition, but understanding where they are will help to keep your perspective accurate. If necessary, sketch the horizon and vanishing points lightly with a pencil to make sure perspective is applied to eveything in your drawing. Once you've established perspective, erase your guidelines and finish the drawing.

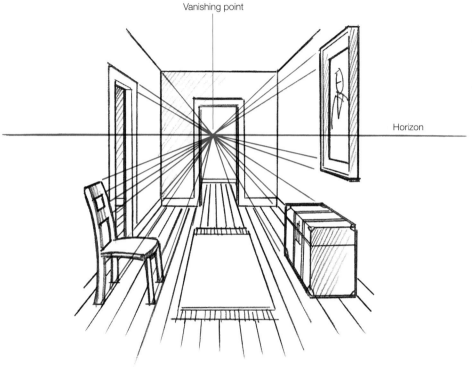

Vanishing point

Horizon

Hide and Seek
Even when the horizon or vanishing points in a scene are hidden, they still affect your drawing. You can easily find your horizon line and vanishing points. If you draw lines from all the parallel elements in this room, they will converge at the vanishing point. Now that you have discovered the vanishing point, you know the horizon line goes through that point in the scene.

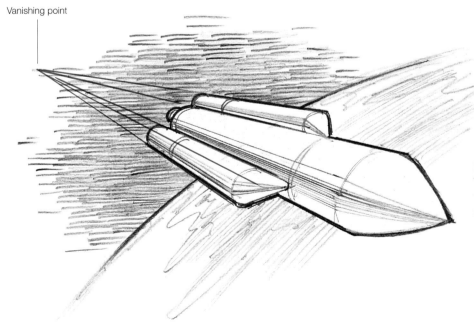

Vanishing point

Beyond the Horizon
Though the subject is not bound to a horizon, this scene still uses the principles of linear perspective.

Locating Vanishing Points

The location of your vanishing points has an important effect on the vantage point of your drawing. The closer the vanishing points are to each other, the closer the object will appear to the viewer. The farther apart they are, the more distant the object will appear to the viewer.

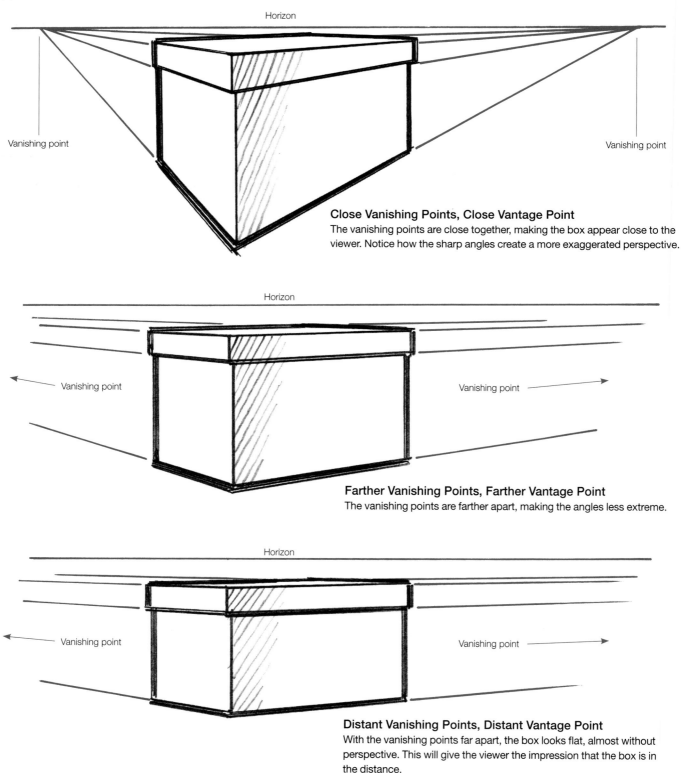

Horizon

Vanishing point

Vanishing point

Close Vanishing Points, Close Vantage Point
The vanishing points are close together, making the box appear close to the viewer. Notice how the sharp angles create a more exaggerated perspective.

Horizon

Vanishing point

Vanishing point

Farther Vanishing Points, Farther Vantage Point
The vanishing points are farther apart, making the angles less extreme.

Horizon

Vanishing point

Vanishing point

Distant Vanishing Points, Distant Vantage Point
With the vanishing points far apart, the box looks flat, almost without perspective. This will give the viewer the impression that the box is in the distance.

Atmospheric Perspective

Atmospheric perspective, also referred to as aerial perspective, uses definition and values to create the illusion of depth and distance. Atmospheric perspective relies on the idea that the closer something is to the viewer, the more it is defined and the more its values contrast. For instance, trees close to the viewer will show more detail and more color variation than trees farther away.

Using Values to Create Depth
In this grouping of trees, the value of the closest trees contrasts more against the background than those farther away.

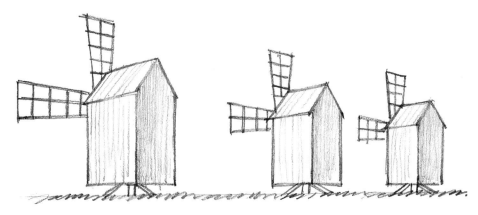

Linear Perspective Only
Depth in this scene relies on the size differences established by linear perspective. The larger windmill seems closer to the viewer than the smaller ones. Atmospheric perspective is not used to show the distance between the windmills.

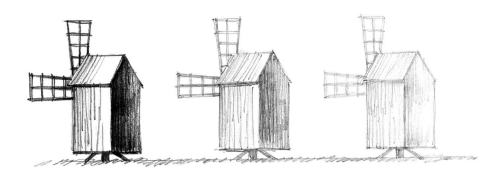

Atmospheric Perspective Only
All three windmills are the same size, so no linear perspective is used. The only difference is the intensity of their values, which makes them look like they are progressively more distant, going from left to right.

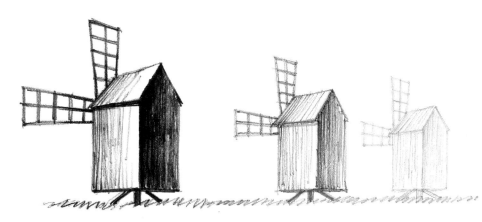

Combined Perspectives
By combining linear and atmospheric perspectives, the depth of the scene is expressed through size and value contrast.

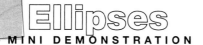

A circle drawn in perspective becomes an *ellipse* because it follows the same principles as other shapes drawn in linear perspective. An ellipse can be made by first sketching a square in perspective. The lines of the square will be used as the boundaries for the ellipse, because both a circle and a square are equally as wide as they are tall.

Must-Have Materials

4H graphite pencil
Drawing board
Drawing paper
Kneaded eraser
White vinyl eraser

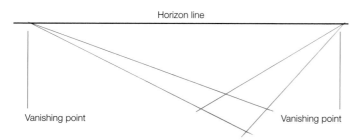

1 Sketch a Square in Perspective
Sketch the horizon line, then place the vanishing points on the horizon. Now sketch a square in perspective by using those vanishing points.

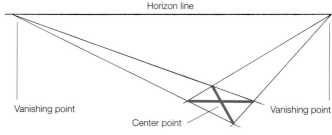

2 Connect the Opposite Corners
Sketch lines connecting the opposite ends of the square. Each line will define the widest and narrowest parts of the ellipse. The intersection of these two lines is the center point of the ellipse.

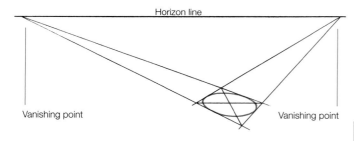

3 Sketch In the Ellipse
Sketch in the shape of the ellipse. Notice that the ellipse is longest in relation to the longest center line.

Ellipses Don't Have Points

Ellipses do not have points on the end. Their ends are round, even if the ellipse is rather flat.

Ellipses In Use

Ellipses can be drawn as vertical, horizontal and angled, but still use the same perspective principles. Remember the first step in drawing an ellipse is to sketch a square in linear perspective.

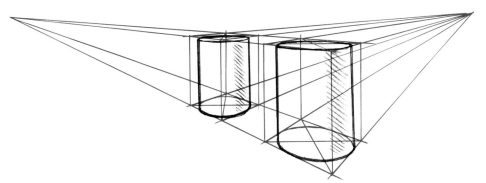

Sketch Cylinders Using Ellipses
The ends of cylinders drawn in perspective are ellipses. First establish the horizon and vanishing points, then sketch the boxes. The ends of the boxes will be the boundaries for the ellipses. Connect the ellipses to create the cylinders.

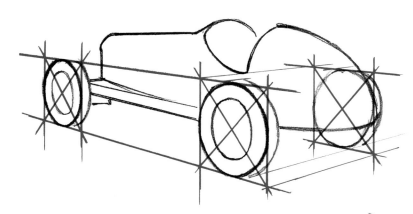

Ellipses Are All Around Us
Ellipses that stand vertically can be drawn in a similar manner. Notice how the center lines direct the shape of each ellipse.

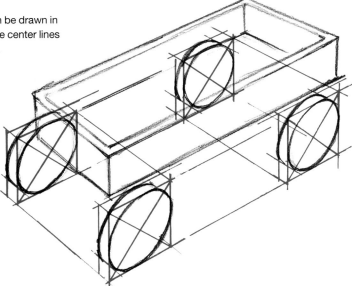

Circles are not the only curved objects you must draw in perspective. Arches are also quite common and need to follow the rules of perspective to look accurate. The peak of an arch is centered over the space between its supporting walls. The same is true of most roofs. To draw a roof in proper perspective, you will need to know how to find its the center point. Measuring with a ruler will not give you the correct center point as far as perspective is concerned, which is why knowing how to find the center point is important. Try this little exercise to learn how to find the center point for a roof.

Must-Have Materials
4H graphite pencil
Drawing board
Drawing paper
Kneaded eraser
White vinyl eraser

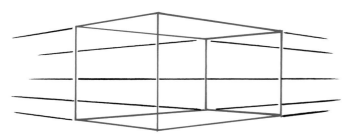

1 Sketch a Rectangle In Perspective
Establish the horizon line, then the vanishing points (which are far off to the left and right). Sketch a rectangle in perspective. This will become the walls that support the roof.

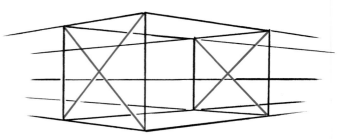

2 Connect Opposite Corners of the Rectangle
Sketch lines connecting the opposite corners of the sides of the rectangle, making two Xs. The intersection of these lines are the center points for the sides.

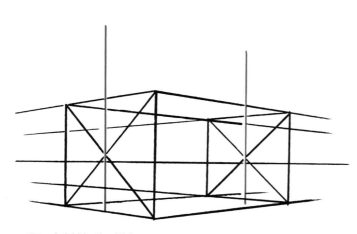

3 Add Vertical Lines
Sketch vertical lines up through the center of the Xs. These lines designate the center of the box's side walls.

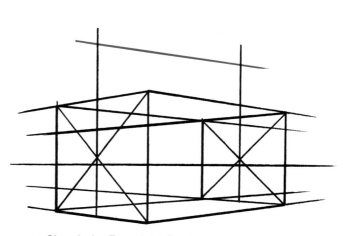

4 Sketch the Top of the Roof
Sketch a line for the top of the roof. If completely drawn, this line would converge with the other lines on the right side of the box at the vanishing point far off to the right.

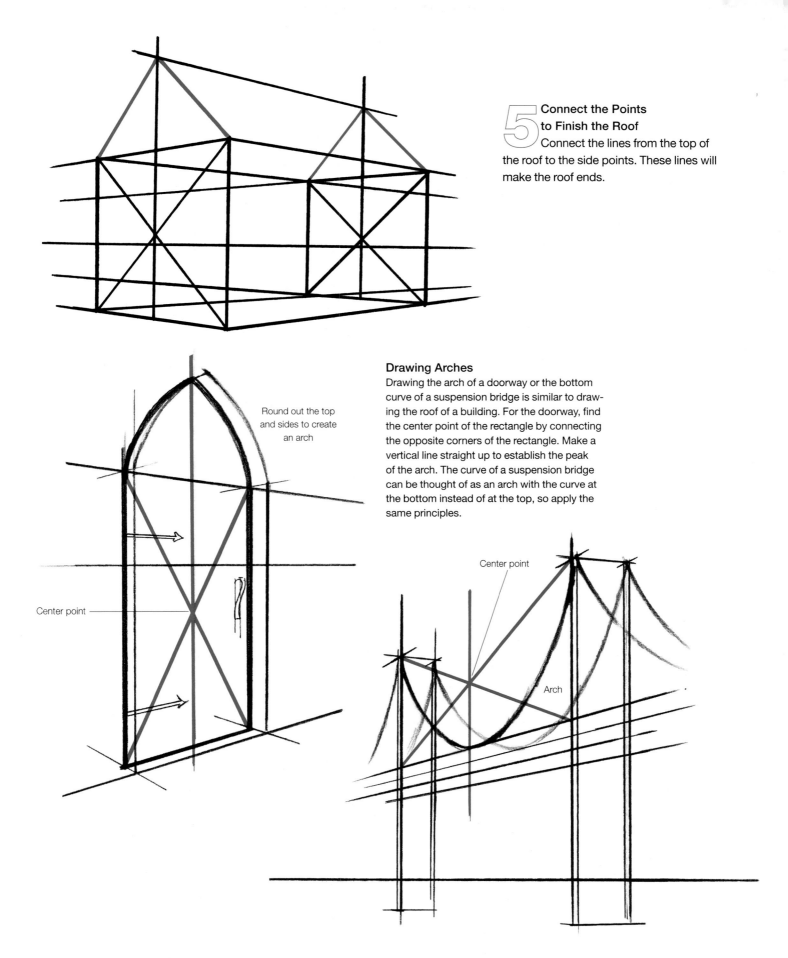

5 Connect the Points to Finish the Roof

Connect the lines from the top of the roof to the side points. These lines will make the roof ends.

Round out the top and sides to create an arch

Center point

Drawing Arches

Drawing the arch of a doorway or the bottom curve of a suspension bridge is similar to drawing the roof of a building. For the doorway, find the center point of the rectangle by connecting the opposite corners of the rectangle. Make a vertical line straight up to establish the peak of the arch. The curve of a suspension bridge can be thought of as an arch with the curve at the bottom instead of at the top, so apply the same principles.

Center point

Arch

Reflections

Reflections are an exciting element to draw because they double the beauty of a scene. The reflection shares the very same horizon and vanishing points as the images they are reflecting.

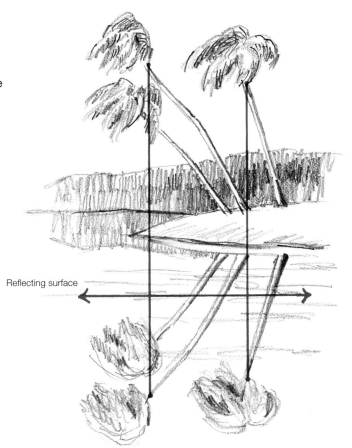

Reflections Are Perpendicular to Their Reflecting Surface

Reflected images are perpendicular to the reflecting surface. The vertical lines show how both the trees and their reflected images are perpendicular to the surface of the water. This is most noticeable when the reflecting surface is smooth.

Reflecting surface

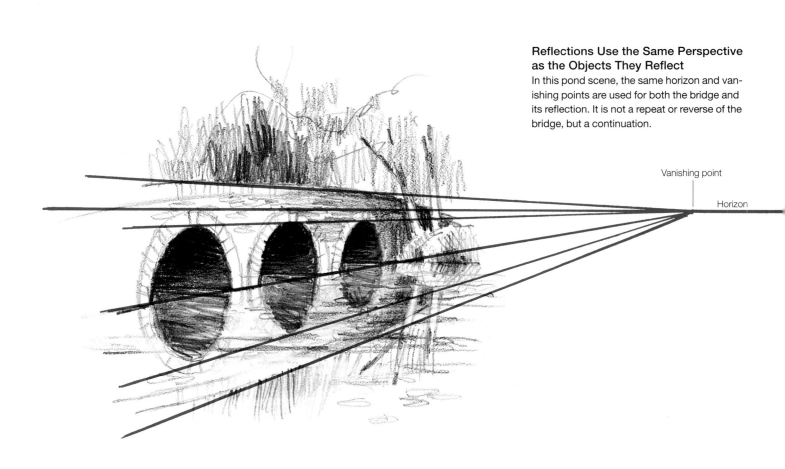

Reflections Use the Same Perspective as the Objects They Reflect

In this pond scene, the same horizon and vanishing points are used for both the bridge and its reflection. It is not a repeat or reverse of the bridge, but a continuation.

Vanishing point

Horizon

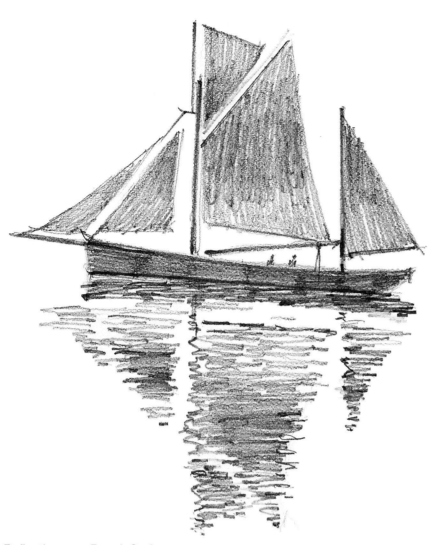

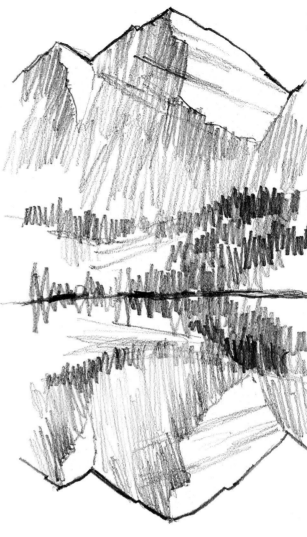

Reflection on a Rough Surface

When the reflection surface is rough, such as when there are waves on the surface of the water, the reflected image is broken up. This occurs because some of the waves are not perpendicular to the image, causing distortion to the image's reflection.

Distant Elements Can Be Reflected

The image reflected doesn't have to be near or directly over the reflecting surface. The mountains are far away from the water, yet their image is still reflected on its surface.

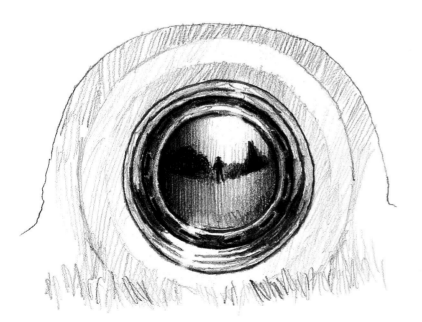

Reflections Can Be a Drawing's Focus

In this example, the reflection on a car's wheel cover shows the sky, ground and trees. Even the person viewing it is visible in the center.

3 Values

Values are the degrees of light and darkness in a drawing. They give additional form and depth to a basic structure. Observing the wide range of values that make up your subject will give you a better understanding of how light creates highlights and shadows on the form.

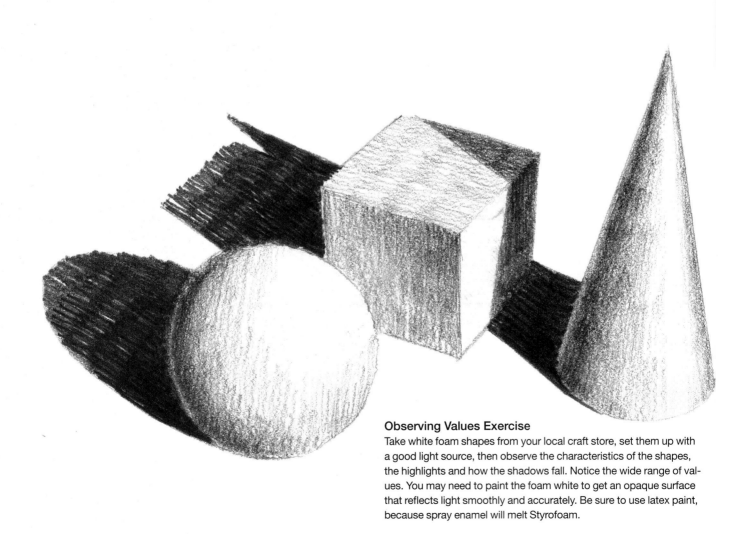

Observing Values Exercise
Take white foam shapes from your local craft store, set them up with a good light source, then observe the characteristics of the shapes, the highlights and how the shadows fall. Notice the wide range of values. You may need to paint the foam white to get an opaque surface that reflects light smoothly and accurately. Be sure to use latex paint, because spray enamel will melt Styrofoam.

Contrast

Differing values create contrasts that can affect the mood and composition of a drawing. The more extreme the difference between values, the greater the contrast. One way to achieve higher contrast in your drawing is to place your darks and lights side by side.

It's All Relative
Value contrasts are relative. They appear differently according to their environment. The small square on the far left may appear darker than the small square on the near left, but both are the same value. The square on the left appears darker because it is placed directly against the pure white of the paper, providing more contrast.

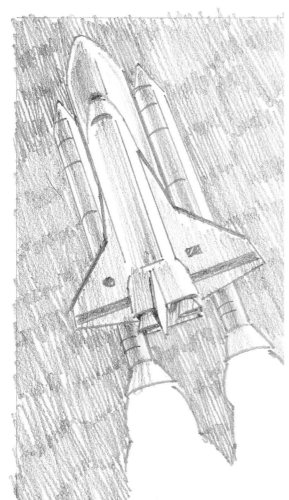

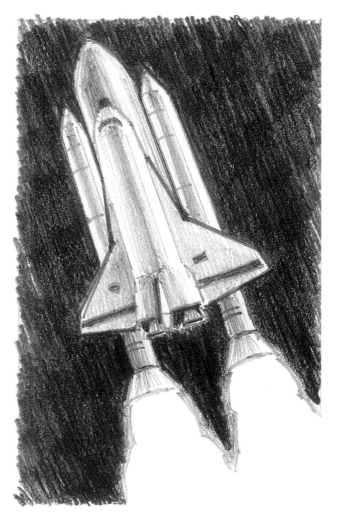

Value Contrast Creates Impact
A drawing done without much contrast will not have much impact and will look flat and pale. The white smoke of the rocket on the right looks brighter against the dark background. The drawing on the right uses richer values, creating more contrast.

Making a Value Scale

You can use a *value scale* to compare the values of a scene with that of a drawing. Hold the value scale up to the subject and look through the holes punched along the side. Where do the values in the subject fall on the value scale? As you begin to compose a drawing (see page 86), it is always best to establish the highlights and very light areas. Sketch those in, then look for where the other values are in the subject. To fill in the other values, one option is to go from the lightest shades of the drawing to the darkest. Another way to map out the values is to fill in some of the darkest areas around the lightest areas, then work with the midtones last. Try each of these methods to see which one works best for you.

Must-Have Materials
4H, HB, 4B graphite pencils
4" × 8" (10cm × 20cm) drawing paper
Kneaded eraser
Hole punch
Scissors
Ruler

1 Draw a Rectangle
Draw a 2" × 6" (5cm × 15cm) rectangle on a 4" × 8" (10cm × 20cm) piece of drawing paper. Add a line down the middle right of the rectangle as a guideline for the holes you will punch out in the last step.

2 Create the Lighter Values
Keeping the top white, use a 4H pencil to create the lighter values with back-and-forth strokes.

3 Add the Middle Values
Add the middle values with an HB pencil.

4 Add the Darkest Values
Use a 4B pencil for the darkest values. With scissors, trim around the rectangle pattern you drew, and punch seven holes along one side with a hole punch.

5 Map Out the Value Variations in Your Reference Photos
Now you can hold your scale up to a picture or scene to judge the values as you work on your drawings.

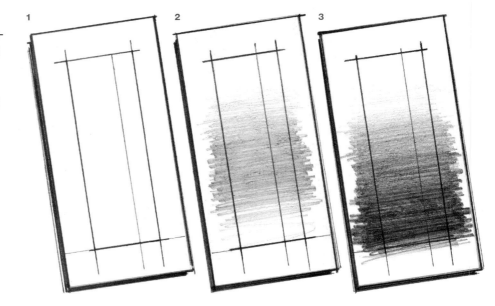

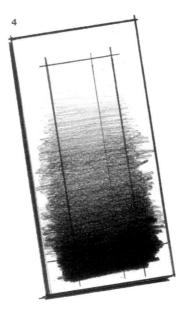

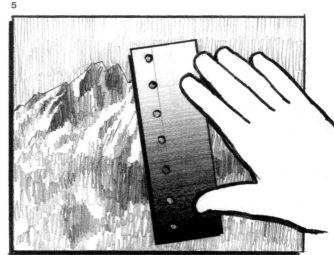

Creating Values

When you draw, you use lines to suggest light and dark values. The grade of pencil, the sharpness of its point, the angle of the point on the paper, the amount of pressure applied to the pencil, and the surface of the paper all influence the values you create. Even the pencil strokes you use influence the values you create on the paper.

Often type of stroke and the direction of the lines is determined by the subject. When drawing wood, the pencil lines will follow the direction of the grain; when drawing a cat, the direction of the pencil lines will follow the contours of its body.

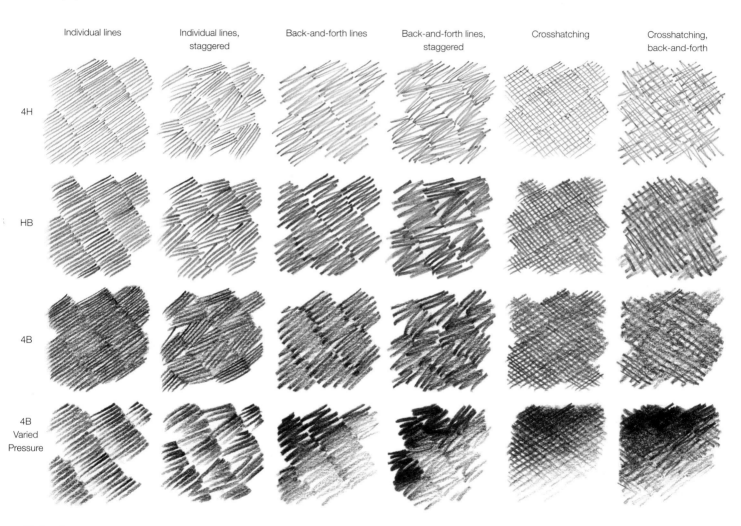

| | Individual lines | Individual lines, staggered | Back-and-forth lines | Back-and-forth lines, staggered | Crosshatching | Crosshatching, back-and-forth |

(Rows labeled: 4H, HB, 4B, 4B Varied Pressure)

Different Folks Make Different Strokes

If you are right handed, it is natural for you to make lines moving from the upper right to the lower left. But lines may go any direction you like, depending on what is comfortable for you and the effect you want to achieve.

Making the Grade

Here are some basic lines strokes created with different pencil grades. Hard pencils are good for sharp, crisp line work, and they keep their points longer than soft pencils. Soft-grade pencils can make smooth, dark values. Consider duplicating these pencil strokes as an exercise, then get creative and invent other textures.

Light Effects

Values are used to create the effects of light and shadow in a drawing. To make your drawings look realistic, you will need to replicate these different light effects.

- **Light Source**. Basically, the origin of the light. To determine the shading and shadows of a scene, it is important to determine the position of the *light source* so you know from which direction the light is coming. The light source is usually the sun or a lamp, so the light usually comes from the top. A light source positioned at the top left or right will give more depth than one located straight above your subject.

- **Highlight**. A *highlight* occurs where light reflects off an object. In a drawing, this appears as a bright spot.
- **Form Shadow**. A shadow on an object that gives depth and dimension to its form.
- **Cast Shadow**. A shadow that is cast or thrown by one object onto another surface.
- **Reflected Light**. Light that bounces off a surface and adds light to a region of the object that would otherwise be darker.

Using Light Accurately Adds Realism and Depth to Your Drawings

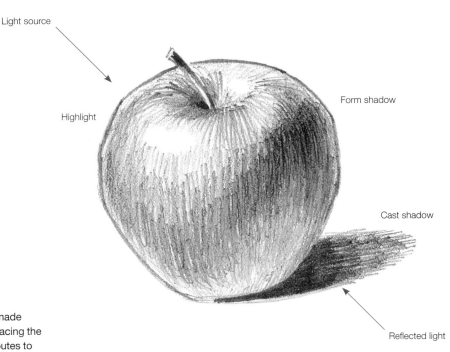

Light source

Highlight

Form shadow

Cast shadow

Reflected light

An Unnatural Light Source

It's more than just a bad haircut that made Frankenstein's monster look scary. Placing the light source below the subject contributes to his fightening looks.

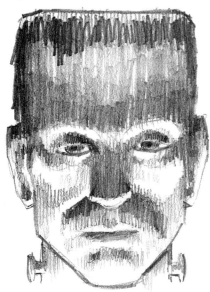

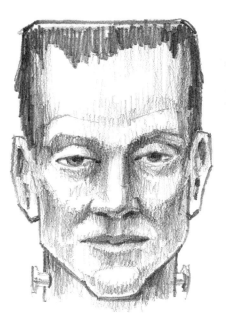

A Natural Light Source

Moving the light source from below the subject to above gives the monster a less frightening appearance.

Plotting Shadows

While the concept of plotting shadows may seem daunting, a basic understanding of it will help you to draw realistically. There are two primary methods of plotting a shadow. One is for when the light source is in the background and can be shown on the drawing; the other is for when the light source is in the foreground and cannot be seen directly. Both of these methods use the principles of linear perspective. You must also plot out the horizon line and vanishing points to be able to get the right perspective for the shape of the object's shadow.

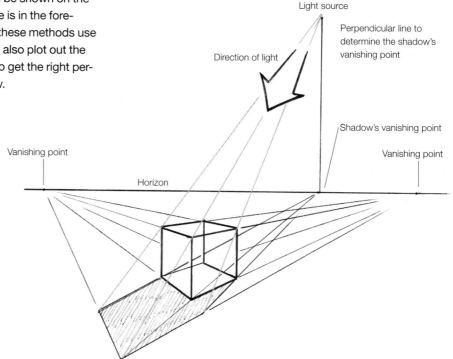

Light Source in the Background

In this example, the light source is in the background. Notice that there is a line coming straight down from the light source to the horizon. That point on the horizon is the shadow's vanishing point. From this vanishing point, draw lines passing through the bottom corners of the cube. Next, draw lines from the light source passing through the top corners of the cube. The intersections between the shadow's vanishing point lines and the light source lines will make the shape of the shadow on the ground.

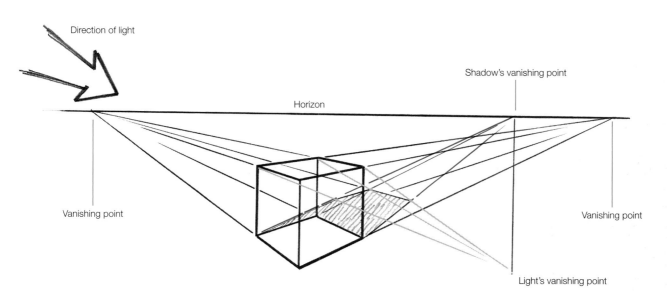

Unseen Light Source in the Foreground

Though the general direction of the light is assumed, the light source is so far away that it cannot be indicated in the drawing. Because of this, the direction of the light and where those lines would converge on the horizon will be a vanishing point. Then draw lines from this vanishing point and pass them through the bottom corners of the cube. Next, plot the lines coming from the vanishing point of the angle of the light source. Place this vanishing point below and perpendicular to the other vanishing point. From this point, draw lines that pass through the top corners of the cube. The intersection of these lines will form the shape of the shadow of the cube.

4 Practice the **Techniques**

You will find certain subjects easier to draw than others. For instance, you may have a knack for drawing faces but feel you can't draw a building in perspective to save your life. When you don't feel comfortable with a certain subject, you will probably try to avoid it, but then you will not gain experience working with that subject. Challenge yourself—give some of the lessons you may deem more difficult a chance. You might even try some lessons more than once, then compare the results from your first attempt with your last. I predict that you will be amazed at the improvement in your drawing skills. You can draw all of these examples with your 4H, HB and 4B pencils. Use the 4H and HB pencils for the light and medium values and the 4B pencil for the darkest values.

Drawing Subjects Are Everywhere
Be on the lookout for drawing subjects such as these rocks. This drawing was done from a photograph taken by one of my students, Jackie Chunko.

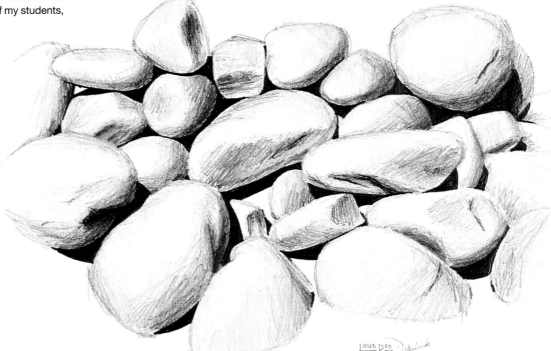

Study of Rocks
Graphite on drawing paper
11" × 14" (28cm × 36cm)

Clouds and Grass

The world around us offers an infinite number of subjects to draw. Commonplace items such as clouds and grass can be interesting by themselves or as complements to other elements in a picture.

When drawing clouds, start by sketching the outline, but use subtle value changes to show the shape and depth of their forms. You can achieve value changes by varying the type or pressure of your pencil strokes. Be particularly conscious of the location of your light source. Stormy days while the sun is still out are especially good for drawing clouds because there are so many sharp contrasts between the lights and darks of the sky.

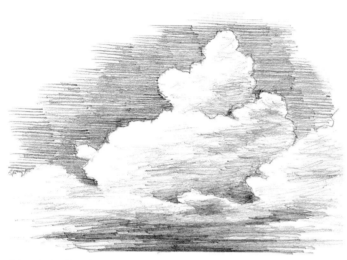

Clouds in Sunlight
With the light source above, the tops of the clouds appear lighter, while the undersides appear darker and shadowed. One way to learn how to draw clouds in sunlight is to study the effects of light on something more solid, such as cotton balls.

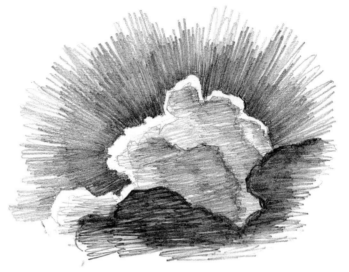

Clouds Blocking the Sunlight
Clouds can be both translucent and opaque. When the light source is behind the clouds, the cloud in front of the sun will appear bright white around the thin, translucent edges where the light shines through it. The thicker parts of the cloud will appear darker because they are more opaque, blocking more of the light.

Grass in Sunlight
Line strokes can imply individual blades of grass. Use darker strokes to indicate shading and depth.

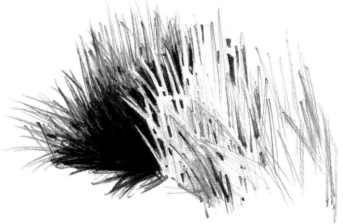

Grass in Sunlight and Shadow
The background grass is shown as a dark silhouette, whereas the foreground grass is suggested with light pencil strokes. Vary the direction and spacing of the lines to make the grass look more interesting.

Leafy Trees
MINI DEMONSTRATION

Trees may be the center of interest in a scene or just a background element. Each tree has a character all its own.

CHECK THIS OUT

Holding the Pencil (p. 15) Creating Values (p. 51)
Using Basic Shapes (p. 27)

Must-Have Materials

Graphite pencil
Drawing board
Drawing paper
Kneaded eraser

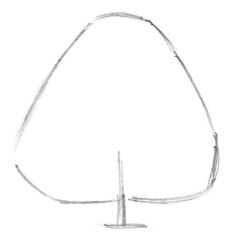

1 Sketch the Basic Shape
Start with the basic overall shape of the tree. Place the trunk toward the bottom of the page.

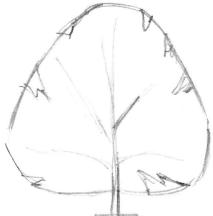

2 Sketch the Branches and Refine the Shape
Sketch in some of the branches. Even if the branches are not visible in the final drawing, sketching them will help you understand both the structure of the tree and the placement of the leaves. Add more definition to the outer form of the tree by outlining the edges of the leaves.

Branch Out

Exposed branches can add interest to an otherwise ordinary tree. First sketch the branches of the tree, then erase the lines that are going to be covered by the leaves. Finally, shade in the leaves.

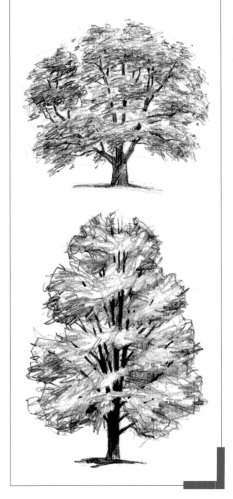

3 Add the Leaves and Shading
Erase any unnecessary lines. Use a variety of back-and-forth lines to suggest the leaves. Make some lines darker than others to create shadows. Notice that the direction of the lines adds a sense of liveliness to an otherwise static subject. Remove your initial outline with an eraser.

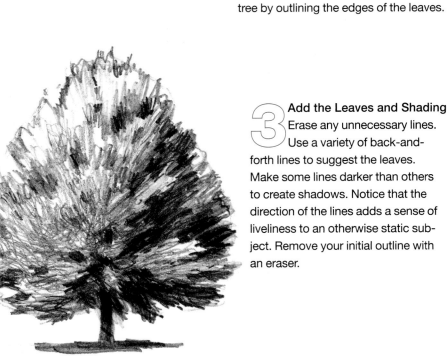

Evergreen Trees

Use the same basic steps to draw evergreens as you would use to draw leafy trees. When drawing a tree, examine the subject closely to capture its uniqueness.

CHECK THIS OUT

Holding the Pencil (p. 15) Creating Values (p. 51)
Using Basic Shapes (p. 27)

Must-Have Materials

Graphite pencil
Drawing board
Drawing paper
Kneaded eraser

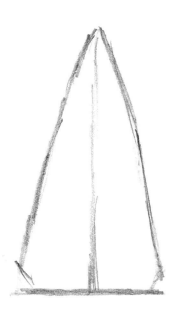

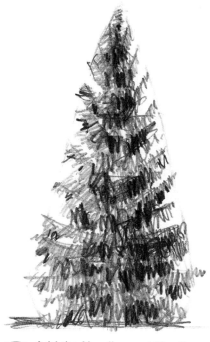

1 **Sketch the Basic Shape**
Start with the basic overall shape and trunk.

2 **Sketch the Branches**
Sketch in the branches, noticing their direction. The branches angle downward the farther down you place them on the tree. Many trees are structured like this, not only evergreens.

3 **Add the Needles and Shading**
Erase any unnecessary lines. Use a variety of staggered back-and-forth lines to suggest the needles of the tree. Apply some lines more heavily than others to create shading and depth.

Carry a Camera

Be on the lookout for interesting trees that you can photograph and use as references for future drawings.

Brick, Stone and Wood

Knowing how to draw different building materials such as brick, stone and wood comes in handy when you want to draw a house. These elements add a range of textures that make your drawing more interesting. Besides, they're fun to draw.

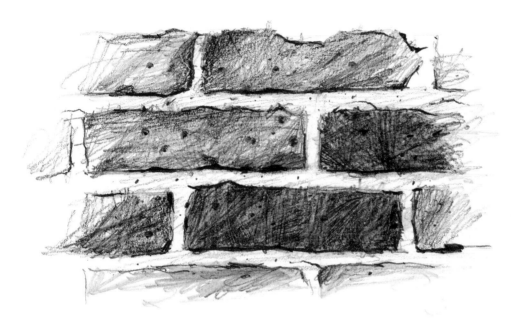

Bricks Up Close
A subject viewed up close will display more texture than when viewed from a distance, so it should be drawn differently to show that detail. To emphasize their worn appearance, draw old bricks with multidirectional lines of varied degrees of thickness.

Bricks at a Distance
A distant view of bricks is drawn with minimal detail. Use back-and-forth line strokes to add values to the bricks. Add shadows under the individual bricks with heavy dark lines for a subtle sense of depth. Also create depth through the use of one-point perspective.

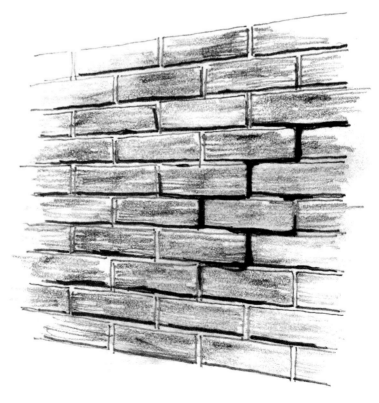

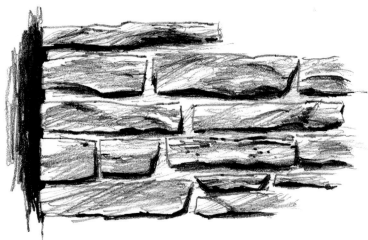

Fitted Stones
Draw the massive fitted stones of an ancient Roman building with shading lines going in different directions to show texture. Make the joints of the stones dark to imply shadow and depth.

Rough Stones
Use irregular shapes and sizes, varied line strokes and shading to create a wall of rough stones. Add heavy, dark lines under the stones to imply shadow and depth. Notice the left end of the wall is set against a background made of dark vertical line strokes to suggest a corner.

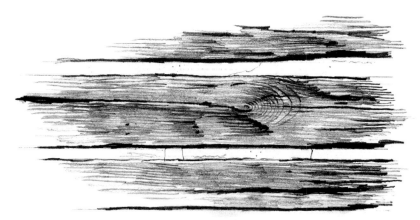

Wood Beams
Draw wood grain using differing values and line strokes. Make the places where the wood was chipped out darker to suggest shadow and depth. Use semicircular lines to create the knots in the boards.

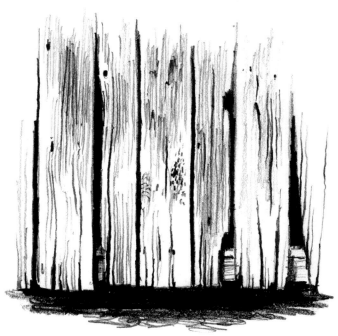

Wood Boards
Draw weathered wood boards with coarse pencil strokes flowing in similar directions to show the grain. The spaces underneath and between the boards are dark to suggest depth.

Rocks

Apply the same drawing principles and techniques that are used when drawing complex subjects to relatively simple subjects such as rocks. You can make the drawing more interesting by varying the shapes and sizes of the rocks.

CHECK THIS OUT

Holding the Pencil (p. 15)
Using Basic Shapes (p. 27)
Gauging Proportions (p. 28)

Creating Values (p. 51)
Light Effects (p. 52)

Must-Have Materials

Graphite pencil
Drawing board
Drawing paper
Kneaded eraser

1 Sketch the Basic Shapes
Sketch the outer shapes of the rocks, varying the sizes and shapes for interest.

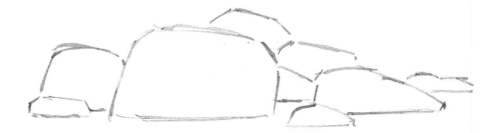

2 Map Out the Lights and Darks
Add lines to map out the lights and darks on the rocks. In this case, the light comes from the upper right, so draw lines on the upper right areas of the rocks for the highlights and on the lower left areas for the darkest portions of the rocks.

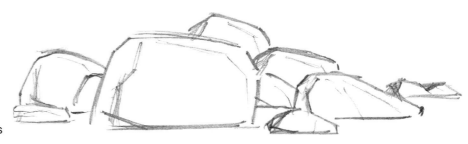

3 Add Shading and Shadows
Use consistent up-and-down pencil strokes so that the surface of the rocks will look smooth. Make the pencil strokes darker on the left side of the rocks to create shading and depth.

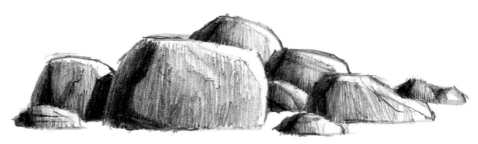

Other Types of Rocks

You may think that if you've seen one rock you've seen them all, but that just isn't true. Rocks offer a variety of shapes, sizes and textures.

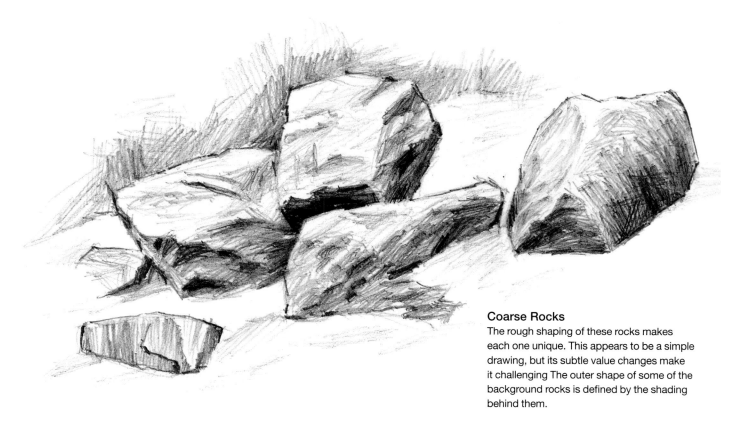

Coarse Rocks
The rough shaping of these rocks makes each one unique. This appears to be a simple drawing, but its subtle value changes make it challenging The outer shape of some of the background rocks is defined by the shading behind them.

Projecting Rocks
These rocks jut upward, their top edges appearing light in value. Use back-and-forth lines to fill in the values, altering the pressure of some of the strokes to add shading and depth.

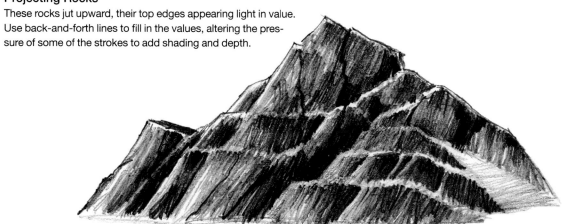

Plane

CHECK THIS OUT

Holding the Pencil (p. 15)
Using a Frisket (p. 15)
Using an Erasing Shield (p. 18)
Gauging Proportions (p. 28)

Two-Point Perspective (p. 36)
Ellipses (p. 42)
Creating Values (p. 51)
Light Effects (p. 52)

Must-Have Materials

Graphite pencil
Drawing board
Drawing paper
Kneaded eraser

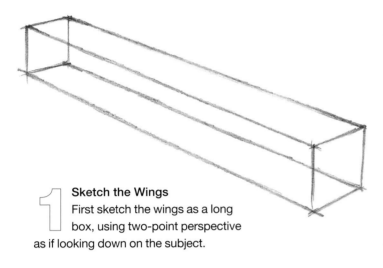

1 Sketch the Wings
First sketch the wings as a long box, using two-point perspective as if looking down on the subject.

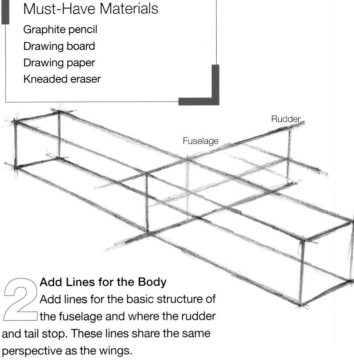

Rudder

Fuselage

2 Add Lines for the Body
Add lines for the basic structure of the fuselage and where the rudder and tail stop. These lines share the same perspective as the wings.

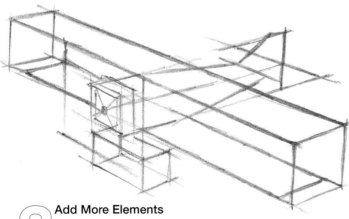

3 Add More Elements and Begin to Refine the Shape
Add boxes to indicate the placement of the wheels and engine area. Draw lines to better define the shapes of the rudder. Chisel out the fuselage and shorten the lower wing tips.

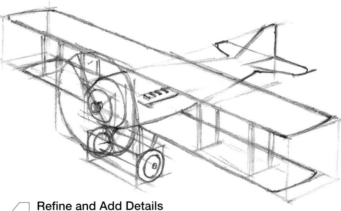

4 Refine and Add Details
Smooth out the lines of the wings and body and add details, including the ellipses of the wheels, engine compartment and propeller.

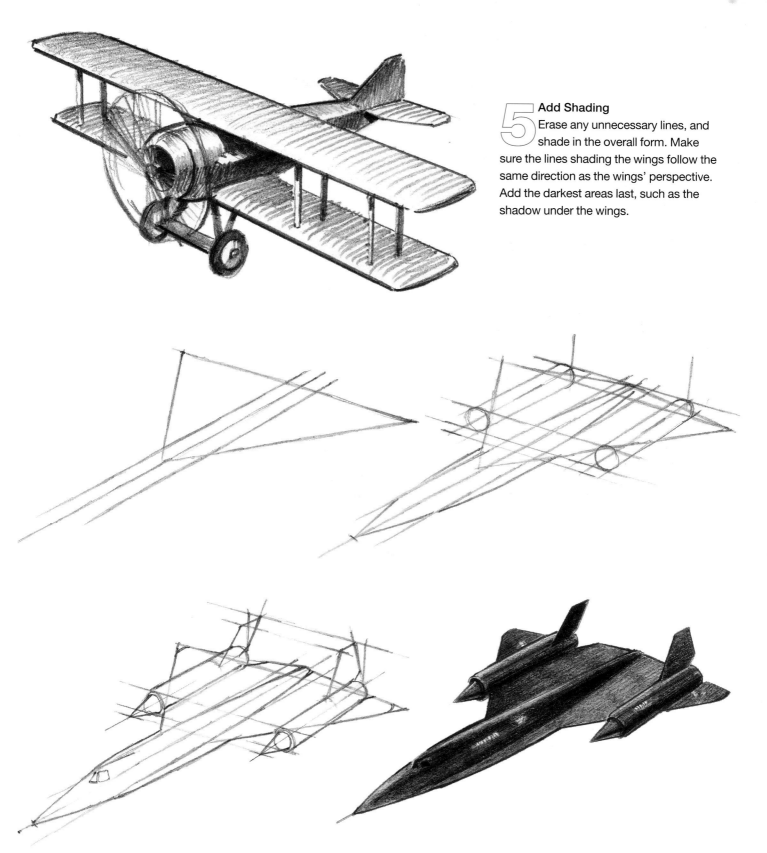

5 Add Shading

Erase any unnecessary lines, and shade in the overall form. Make sure the lines shading the wings follow the same direction as the wings' perspective. Add the darkest areas last, such as the shadow under the wings.

Draw A High-Speed Jet
First draw the basic shapes in perspective to carve out the shape of the plane. Add highlights, shadows and details.

Train

This type of steam engine is a Norfolk and Western 4-8-4. The structural elements of this scene are drawn using one-point perspective. Make use of the principles of atmospheric perspective as you apply the lights and darks. When you want to shade subjects like these, friskets and erasing shields may be handy tools to use.

Must-Have Materials

Graphite pencil
Drawing board
Drawing paper
Kneaded eraser

CHECK THIS OUT

Holding the Pencil (p. 15)
Using a Frisket (p. 15)
Using an Erasing Shield (p. 18)
Gauging Proportions (p. 28)

One-Point Perspective (p. 34)
Atmospheric Perspective (p. 41)
Creating Values (p. 51)

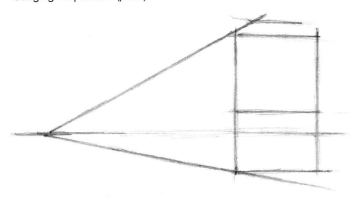

1 Sketch the Basic Shapes
Draw the horizon line, with the vanishing point on the left side. Start with the basic shape in one-point perspective. Notice that all the vertical lines are perpendicular to the horizon at this stage.

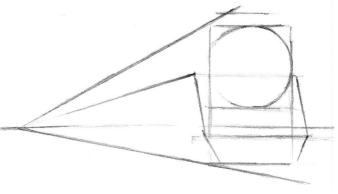

2 Indicate the Basic Shapes of the Front
Fill the previously drawn square with a circle. Add other lines to indicate the basic shaping of the front of the engine.

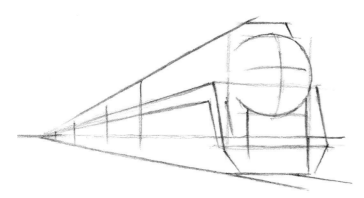

3 Add More Structural Lines
Add the more obvious lines, including the vertical lines that define the individual cars. Add a cross in the upper middle of the circle, to mark the placement of the engine lights.

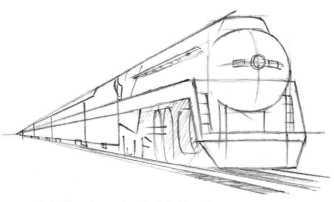

4 Add Details to the Train's Structure
Add the tracks, wheels, engine light and smaller details such as the handrail and the steps. Also add trim to the tops of the cars.

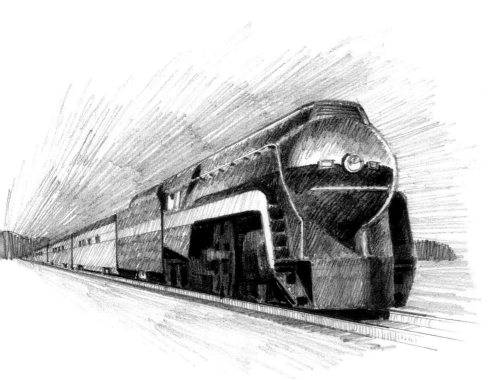

Add Shading
5 Erase any unnecessary lines, and finish with shading. Use uniform up-and-down pencil strokes to make a smooth appearance. Create atmospheric perspective by drawing the closer portion of the train with more contrasts and details than the more distant portion.

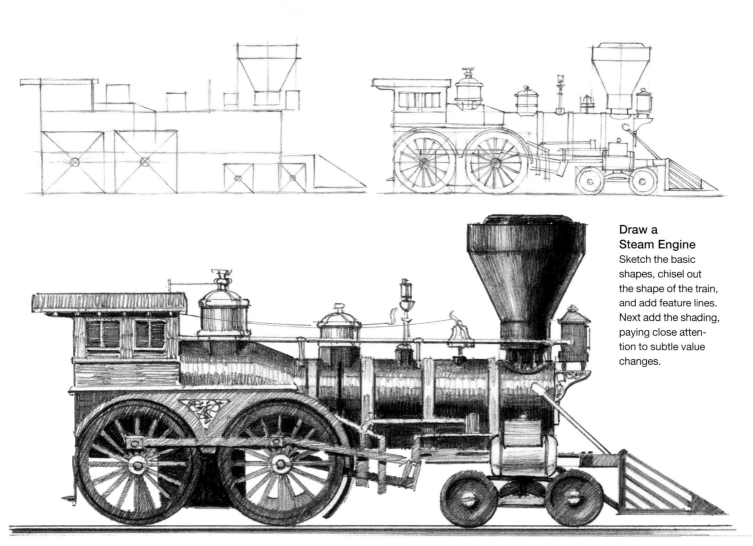

Draw a Steam Engine
Sketch the basic shapes, chisel out the shape of the train, and add feature lines. Next add the shading, paying close attention to subtle value changes.

Automobile

This is a Facel Vega, a French sports car built in the 1950s and 1960s. This is a fun lesson to practice dissecting your subjects by first looking for the basic shapes, remembering the rules of perspective.

CHECK THIS OUT

Holding the Pencil (p. 15)
Gauging Proportions (p. 28)
Two-Point Perspective (p. 36)
Ellipses (p. 42)
Creating Values (p. 51)

Must-Have Materials
Graphite pencil
Drawing board
Drawing paper
Kneaded eraser

1 Sketch the Basic Shapes
Sketch a basic box shape in two-point perspective. Take the time to get this right so the rest of the drawing will work out accurately.

2 Add the Top and Squares for the Wheels
Add the top of the car to the basic shape. Draw squares in perspective to indicate the wheels' placement. This will help you draw the ellipses for the tires accurately. Like all the elements, the squares share the same perspective as the basic box shape.

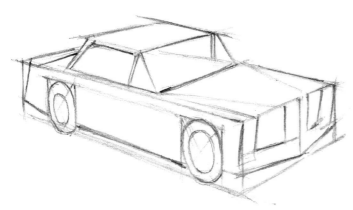

3 Add and Refine the Structural Lines
Chisel out the shape of the car, and sketch in ellipses for the wheels. Add lines to mark the placement of the front elements such as the grill and headlights.

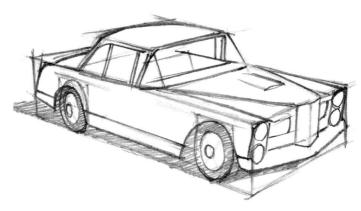

4 Add Details and Begin Shading
Add details such as the headlights, grill, windows and interior. Keep in mind that the cutouts for the wheel are shaped differently from the wheels themselves. Add some shading to the wheels and shadow under the car.

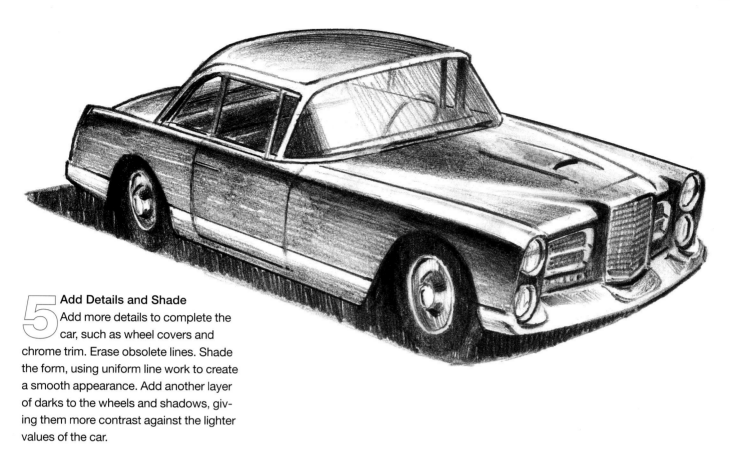

5 **Add Details and Shade**
Add more details to complete the car, such as wheel covers and chrome trim. Erase obsolete lines. Shade the form, using uniform line work to create a smooth appearance. Add another layer of darks to the wheels and shadows, giving them more contrast against the lighter values of the car.

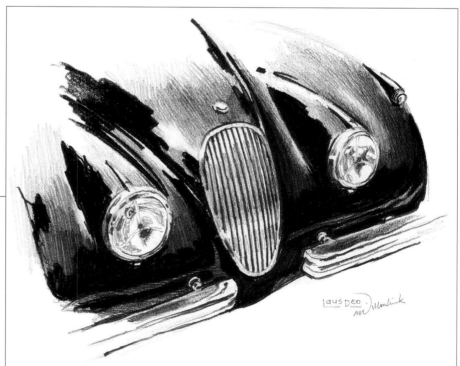

Creating a Shiny, Metallic Surface

Rich darks and graduated values give this Jaguar a shiny metallic appearance. It is important to make uniform pencil lines to create the smooth, metallic look for the car's surface.

Boat

The graceful lines of boats and shimmering water reflections inspire great compositions. For this demonstration, we'll start with a simple side view.

CHECK THIS OUT

Holding the Pencil (p. 15)

Using Basic Shapes (p. 27)

Gauging Proportions (p. 28)

Locating Vanishing Points (p. 40)

Must-Have Materials

Graphite pencil

Drawing board

Drawing paper

Kneaded eraser

1 Sketch the the Lines of the Hull
Start with the lines of the hull, which tilt slightly upward on the left side.

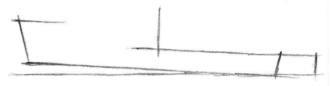

2 Finish the Basic Shape of the Hull and Indicate the Cabin
Connect the ends to complete the basic shape of the hull. Add lines to indicate the placement of the cabin.

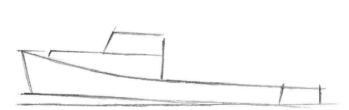

3 Add the Side of the Cabin and the Top of the Hull
Draw the side of the cabin and the curve of the top of the hull. The boat is viewed from the side and at a distance, making it look flat.

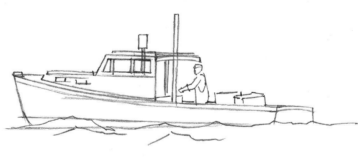

4 Add Details
Sketch in details, including windows, trim and the man.

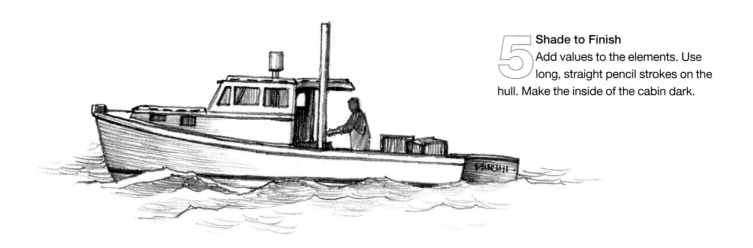

5 **Shade to Finish**
Add values to the elements. Use long, straight pencil strokes on the hull. Make the inside of the cabin dark.

Sketch a Rowboat

Sketch the basic shapes in perspective, then add details and shading.

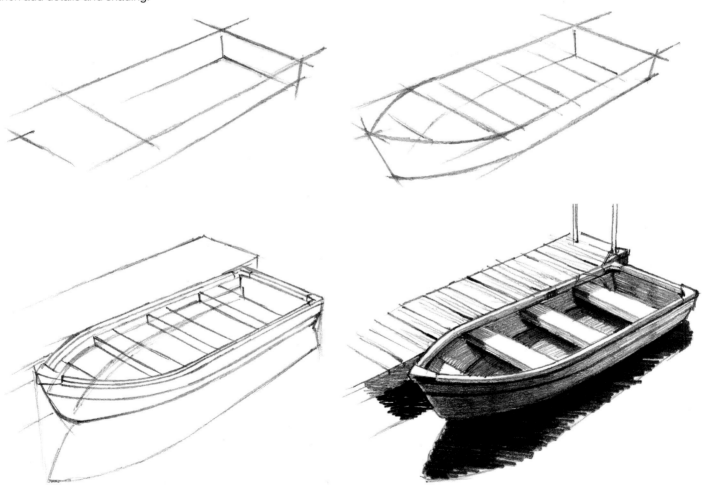

Cat Face

For those of you who are cat lovers, this demo will be lots of fun. For those of you who prefer dogs (we know everyone falls under one of the two categories), go ahead and try this exercise, then give the finished art to one of your cat-loving friends. This demo offers a great way to develop your shading skills.

CHECK THIS OUT

Holding the Pencil (p. 15) Gauging Proportions (p. 28)
Using Basic Shapes (p. 27) Creating Values (p. 51)

Must-Have Materials

Graphite pencil
Drawing board
Drawing paper
Kneaded eraser

1 Sketch the Basic Shapes
To draw the feline face, start with the basic outer oval, two lines for the top and bottom of the eyes, and an oval for the snout.

2 Place the Facial Elements
Add more lines for the eyes, mouth and the top of the ears, as well as a triangle for the nose.

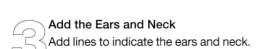

3 Add the Ears and Neck
Add lines to indicate the ears and neck.

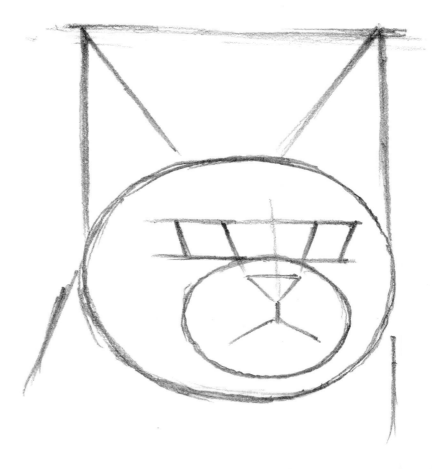

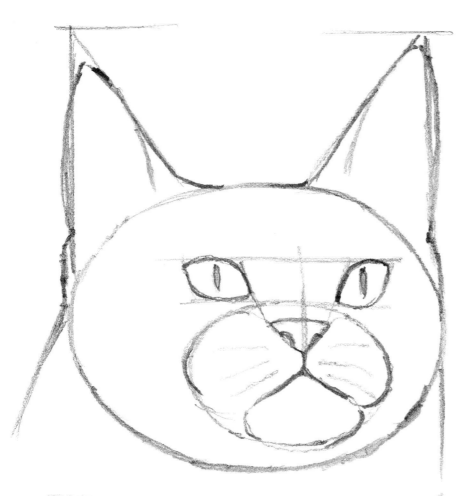

4 Refine the Lines and Add Details
Refine the structural lines, rounding and curving where necessary. Add details, including the pupils, nose and muzzle.

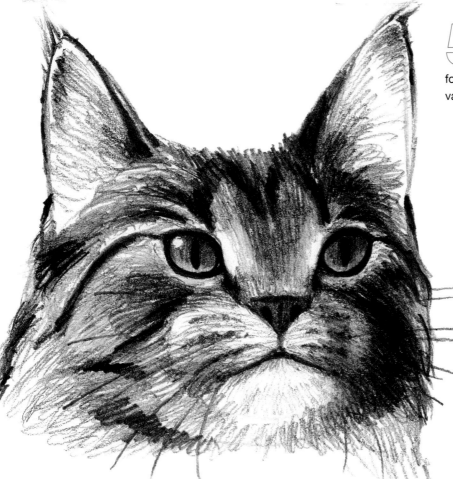

5 Add Shading
Erase any obsolete lines. Add shading with pencil strokes that follow the direction of the fur. Apply darker values for the stripes and shadows.

Side View of a Cat

Cats are as varied as people, and it is fun to capture their unique qualities in your drawings. In addition to helping you create shape and texture, this demo will give you an opportunity to work on developing your proportioning skills. To sketch the legs and body in the correct proportions, first sketch a *baseline*. A base-line is used to establish the placement of your subject and to help work out proportions of a drawing.

Must-Have Materials

Graphite pencil
Drawing board
Drawing paper
Kneaded eraser

CHECK THIS OUT

Holding the Pencil (p. 15) Gauging Proportions (p. 28)
Using Basic Shapes (p. 27) Creating Values (p. 51)

1 Sketch the Basic Body Shape
Draw a rectangle to suggest the basic body structure. Take the vertical lines all the way down to the baseline.

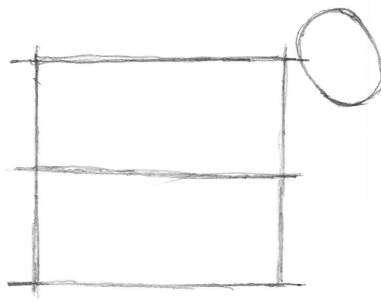

2 Add the Head Shape
Sketch an oval for the head. Position it so it just overlaps the top horizontal line.

3 Add the Neck and Legs
Add lines for the neck that connect the head to the body. Sketch angled lines for the legs. See page 30 for instructions on how to transfer angles.

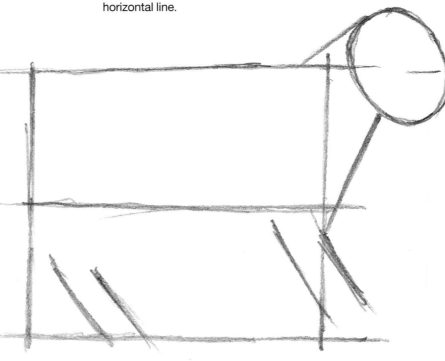

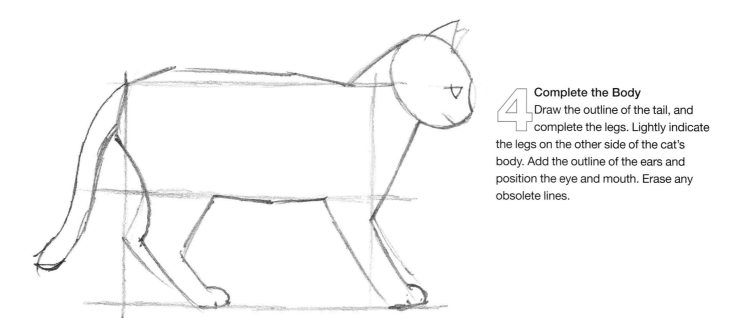

Complete the Body

Draw the outline of the tail, and complete the legs. Lightly indicate the legs on the other side of the cat's body. Add the outline of the ears and position the eye and mouth. Erase any obsolete lines.

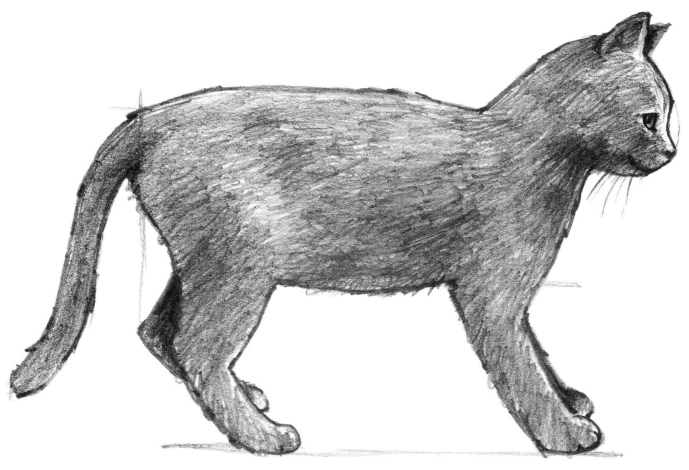

Add the Shading and Details

Use back-and-forth strokes to suggest the cat's fur, varying the lights and darks to imply form. Add details to the eye, mouth, nose, ear and paws.

Side View of a Dog

Use the steps you practiced on the cat's body (see page 72) to draw a dachshund. Start with the basic overall structure and then add more features as your drawing progresses. While observing dachshunds for this drawing, I became aware of how short dachshunds really are!

CHECK THIS OUT

Holding the Pencil (p. 15) Gauging Proportions (p. 28)
Using Basic Shapes (p. 27) Creating Values (p. 51)

Must-Have Materials
Graphite pencil
Drawing board
Drawing paper
Kneaded eraser

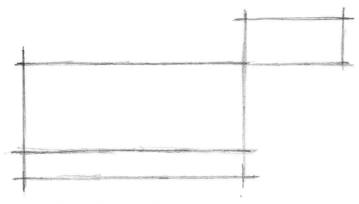

1 Sketch the Basic Shapes
Sketch lines to form the basic body and head structure, including a baseline to establish where the feet will rest.

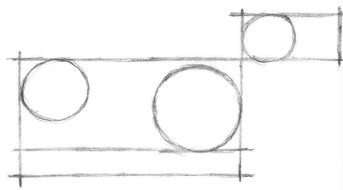

2 Add Circles for the Head and Body
Add circles for the head, chest and rear. This will help you shape the dog's overall form.

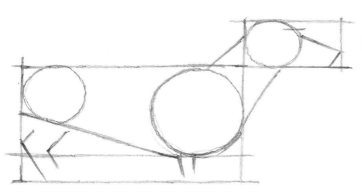

3 Add Lines for the Body, Neck and Legs
Connect the circles to form the shape of the body and neck. Sketch lines that will indicate the muzzle and the foreground legs.

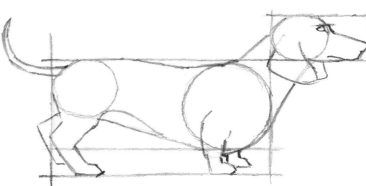

4 Refine Lines and Add Structural Details
Refine the line work to further shape the dog's body. Add the eye, tail, ears and legs. Place the background legs so they are staggered in comparison to the foreground legs.

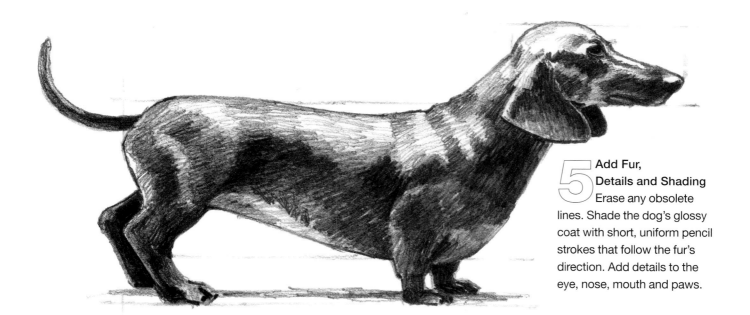

5 Add Fur, Details and Shading

Erase any obsolete lines. Shade the dog's glossy coat with short, uniform pencil strokes that follow the fur's direction. Add details to the eye, nose, mouth and paws.

Drawing Long Fur

Use long pencil strokes that follow the direction of the fur to shade in the coat for a longhaired dog. Make these pencil strokes less uniform than those used for a shorthaired dog. This will make the long fur look more textured.

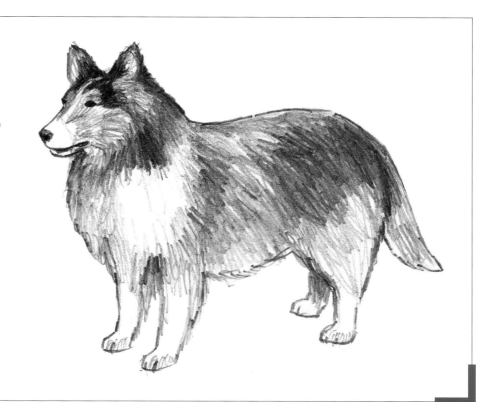

Cow
MINI DEMONSTRATION

Cows are incredible creatures. Besides giving us milk, cheese and meat, cows do amazing tricks, but no one knows about it because they pull these stunts only when no one is looking.

CHECK THIS OUT

Holding the Pencil (p. 15)
Using Basic Shapes (p. 27)
Gauging Proportions (p. 28)
Creating Values (p. 51)

Must-Have Materials

Graphite pencil
Drawing board
Drawing paper
Kneaded eraser

1 Sketch the Basic Shapes
Sketch the basic shapes: a rectangle for the body and a triangle for the head. Add a baseline to establish the length of the legs.

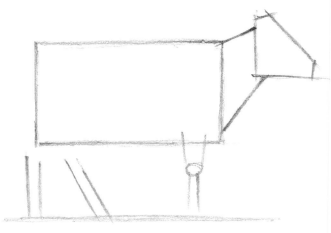

2 Indicate the Neck and Legs
Add lines for the neck and legs. Pay attention to the placement and angles of these lines. Use a small circle to indicate the joint of the front knee.

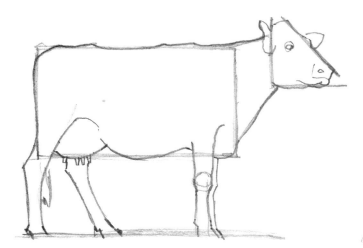

3 Refine the Lines
Refine the line work to further shape the cow's body. Add the eye, ears, tail and udders.

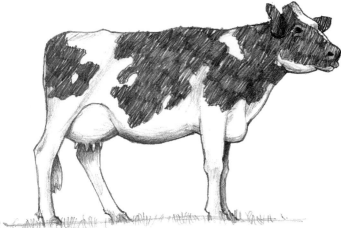

4 Add Shading and Finishing Details
Erase any extra lines. Add light shading to imply form, using darker shading in the more shadowed places. Make the coat's dark patches with semi-uniform back-and-forth pencil strokes.

Swan
MINI DEMONSTRATION

The elegant lines of this swan makes it an interesting subject. Enjoy practicing your skills with this mini demo and then consider using your drawing as a greeting card.

CHECK THIS OUT

Holding the Pencil (p. 15) Measuring Proportions (p. 28)
Using Basic Shapes (p. 27) Creating Values (p. 51)

Must-Have Materials
Graphite pencil
Drawing board
Drawing paper
Kneaded eraser

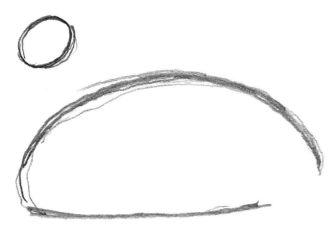

1 Sketch the Basic Shapes
Sketch the basic shapes of the head and body. Be conscious of their proportions and placement.

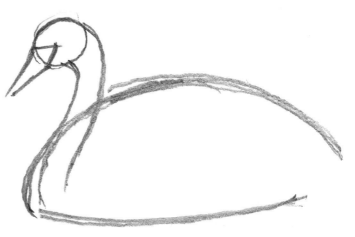

2 Add the Neck and Beak
Add curved lines for the neck, then add the beak, paying attention to the distance between the neck lines.

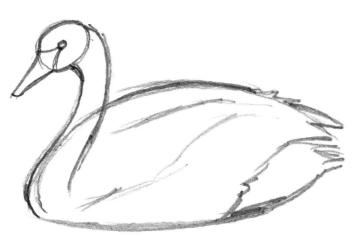

3 Sketch in the Feathers
Indicate the feather placement on the swan's back, and add the eye to the head.

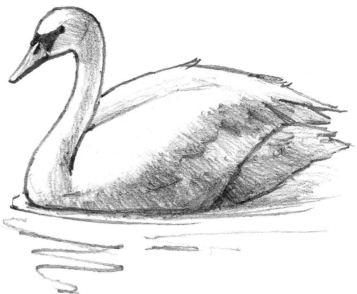

4 Add Final Details and Shading
Add the shading with short pencil strokes. Start with the lighter values, then add another layer of pencil strokes for the darker areas.

Human Figures

People make fascinating subjects to draw. While at a mall, just look at all the different sizes, shapes and proportions of the people around you. Though you may observe that people come in many different "varieties," there are basic principles that apply to all humans.

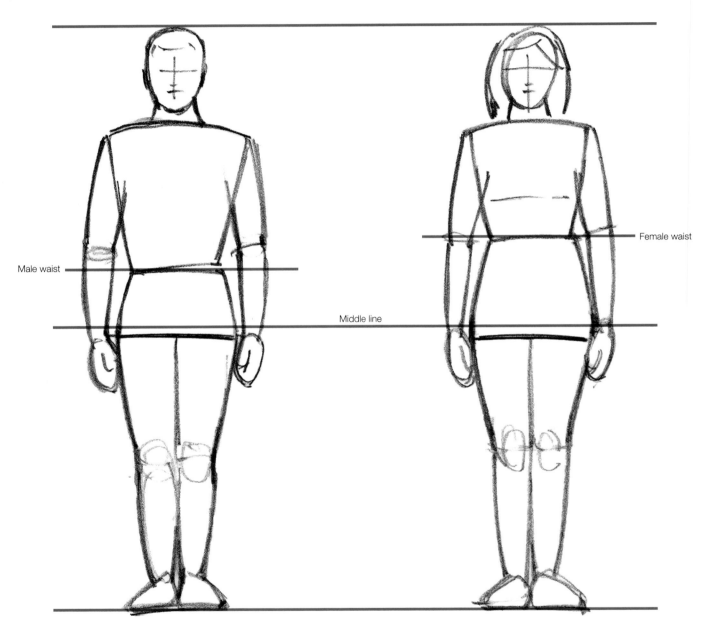

Proportions for Adults

Though men are generally taller than women, they are shown as the same height here for comparison. For both sexes, almost half the height is made up of the legs, with the tips of the hands falling to the mid-thigh region. The waist is lower in men than in women. Another difference is that men are generally bulkier and wider than women.

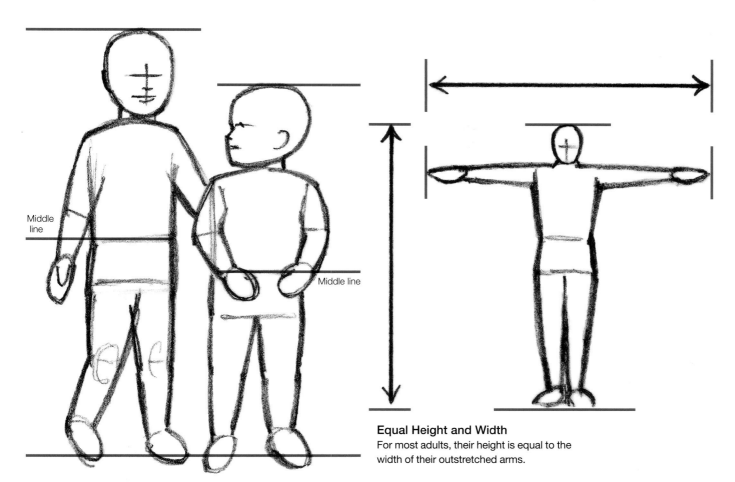

Middle line

Middle line

Equal Height and Width
For most adults, their height is equal to the width of their outstretched arms.

Proportions for Children
Children are proportioned differently from adults, more noticeably in younger children. Their bodies are smaller in relation to their heads, and their legs are shorter, with the tops of their legs well below the middle line.

Figure Drawing
Once you become familiar with basic body structure and proportions, you can draw more confidently, using a minimum of structural guidelines.

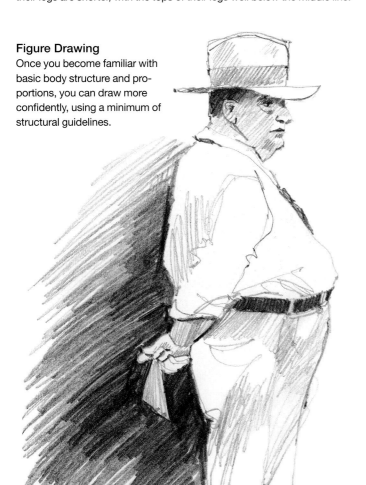

Structural Sketch
This sketch has its structural elements blocked in.

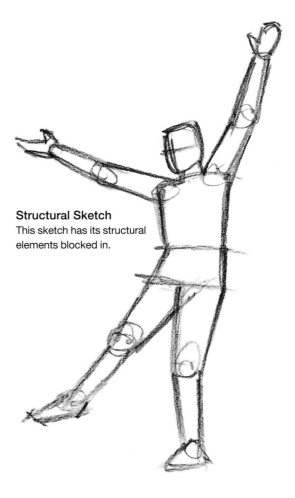

Man Standing

As you draw the human figure, remember that almost half the height of the body is the legs. Establish the middle line first, then mark the top of the inseam. Pay attention to the head size, which takes up a little more than one-eighth of the overall height. A common mistake in figure drawing is to make the head too large and the legs too short.

CHECK THIS OUT

Holding the Pencil (p. 15) Gauging Poportions (p. 28)
Using Basic Shapes (p. 27) Creating Values (p. 51)

Must-Have Materials

Graphite pencil
Drawing board
Drawing paper
Kneaded eraser

1 Establish the General Proportions
Start with lines to indicate the placement and proportions. Because the weight of the body in this example rests over the man's right leg, include a vertical line that goes from the head to the right foot.

Add top, bottom and middle horizontal lines. Then sketch a line halfway between the middle and top lines, then sketch another line between the last line drawn and the top line.

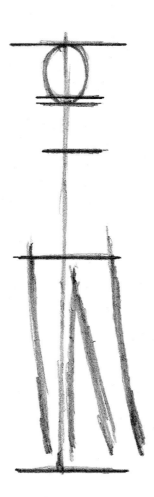

2 Sketch the Head and Legs
Most adults are about 7½ heads high. The distance from the top line to the next lower line is one-eighth of the overall height. Make a line slightly lower and sketch an egg shape for the head, which should work out to about 7½ units of the overall height. You can use dividers if you want to check your proportions. Sketch in the legs, placing the top of the inseam just below the middle line.

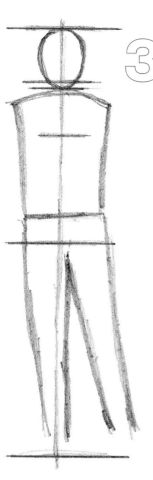

3 Add the Torso and Waist
Sketch the basic shape of the torso along with the waistline.

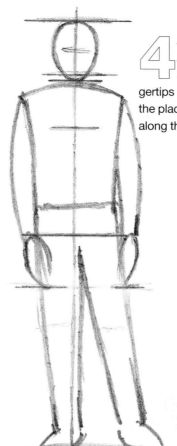

4 Add the Arms, Hands and Feet
Add the arms, with the wrists falling at about the middle line and the fingertips reaching mid-thigh. Sketch a line for the placement of the eyes. Sketch in the feet along the baseline.

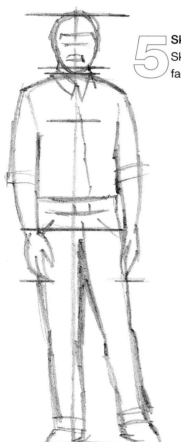

5 Sketch in Details
Sketch in the details, including facial features and clothes.

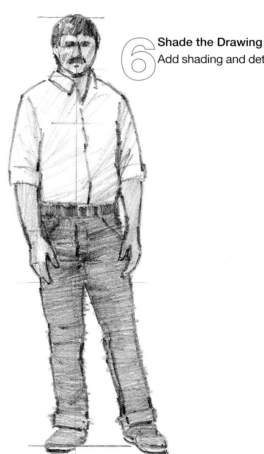

6 Shade the Drawing
Add shading and details.

Face: Front View

To draw faces correctly, it's important to understand their basic structures and proportions. One way to do this is to use the width of the eye as a unit of measurement. These examples show generic proportions of an adult male of European origin. The features of individuals vary according to age, gender and ethnicity, if only in subtle ways.

1 Sketch the Basic Shape
Start with the basic shape egg-shape of the head. It should be five eye-widths wide by seven eye-widths high.

2 Add the Eye Line
Sketch a horizontal line in the middle of the face to place the eyes. Sketch a vertical line to establish the center of the face.

3 Add Eye Shapes and Nose and Mouth Lines
Sketch the eyes, leaving one eye-width between them. Add a line for the nose a little less than half the distance from the eyes to the chin. Sketch a line for the mouth a little less than halfway between the line for the nose and chin.

4 Add Eyebrows and Lips
Add a horizontal line above the eyes for the eyebrows and sketch them in. Add the top and bottom lips.

5 Add the Nose and Ears
Add the base of the nose. The width of the nose aligns with the inside corners of the eyes. Add the ears, with the tops of the ears aligned with the eyebrows and the bottoms aligned with the base of the nose.

6 Add Details
Add details to the eyes and nose, along with the hair and neck.

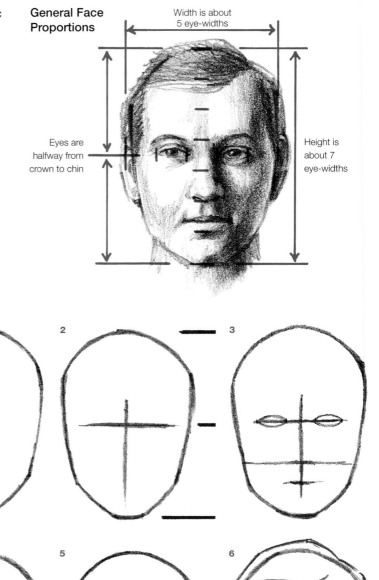

General Face Proportions

Width is about 5 eye-widths

Eyes are halfway from crown to chin

Height is about 7 eye-widths

Face: Three-Quarters View

A three-quarters view of the face shows most of the face and part of the side of the head. Keep in mind that the proportions and the placement of the elements are similar to the front view.

Must-Have Materials
Graphite pencil
Drawing board
Drawing paper
Kneaded eraser

1 Sketch the Basic Shape
Sketch an egg-shape for the three-quarters view with the chin slightly off-center toward the right.

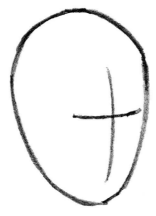

2 Add the Eye Line
Add a slightly off-center horizontal line for the eyes. Sketch a vertical line through the middle of the eye line to establish the center of the face.

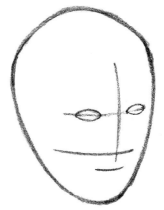

3 Add Eye Shapes and Lines for the Nose and Mouth
Sketch the shapes of the eyes with one eye-width between them. Add a line for the nose a little less than half the distance from the eyes to the chin. Sketch a line for the mouth a little less than half the distance between the line for the nose and the chin.

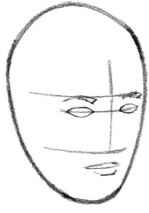

4 Add Eyebrows and Lips
Add a line to place the eyebrows, then sketch in the eyebrows. The curve of the brows should follow the curve of the eyes. Add the top and bottom lips.

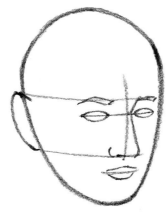

5 Add the Nose and Ear
Add the nose. Working down, the nose bridge should angle in toward the center of the eyes and then angle out from the center to the base of the nose. Add the ear, with the top aligning with the eyebrows and the bottom aligning with the nose's base.

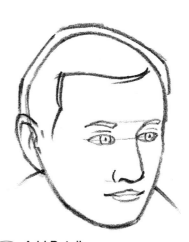

6 Add Details
Add details to the eyes and nose, along with the hair and neck.

Face: Side View

Placing the elements for a side view of a face is similar to that for the front and three-quarters view. As with all drawings, look for proportions and places where the elements align. You may want to examine the proportions with a tool such as a pencil, dividers or a sewing gauge (see page 28).

Must-Have Materials
Graphite pencil
Drawing board
Drawing paper
Kneaded eraser

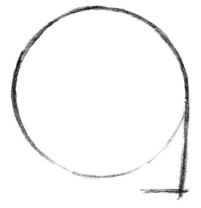

1 Sketch the Basic Shapes
Sketch a circle for the top and middle portion of the head. Sketch a vertical line down from the right side of the circle for the front of the face. Add a short horizontal line at the end of the vertical line, slightly lower than the circle, as the base of the chin.

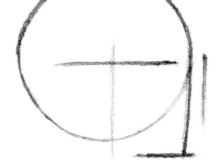

2 Add Lines for the Eye, Nose and Ear
Sketch a horizontal line, halfway between the top of the chin, the circle and the base of the chin, for the placement of the eye. Sketch a vertical line to the right of the circle to help with the placement of the nose. Another vertical line, coming from the center of the circle, will help with the placement of the ear.

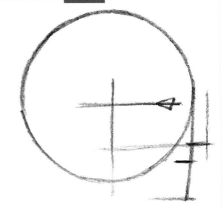

3 Add the Eye Shape and Lines for the Nose and Mouth
Sketch a triangle for the eye, placing it about a third of the distance from the right edge of the circle to the vertical line for the ear. Sketch a horizontal line a little less than half the distance from the eye line to the chin line for the base of the ear. Add a short horizontal line a little less than half the distance from the previously established nose line to the chin line to help place the mouth.

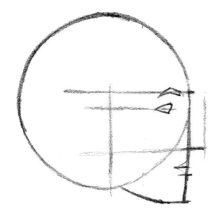

4 Add Eyebrows and Lips
Add a horizontal line for the eyebrow. Sketch the eyebrow, making it slightly curved. Add lines for the lips, connecting them to the vertical line in the front of the face.

5 Add the Ear and Form the Profile
Sketch the ear shape, placing it slightly left of the central vertical line and from the brow line to the nose baseline. Form the profile of the face and complete the jawline, which ends near the lower right part of the ear.

6 Add Details
Add details to the eyes, ears and nose. Add the hair and neck.

Drawing Individual Faces

Most adult faces have similar overall proportions, with the differences being most noticeable in the features such as the eyes, nose, ears and lips.

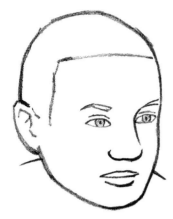

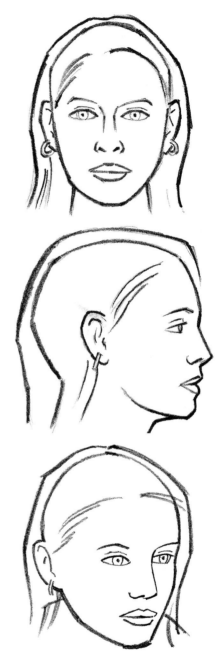

Ethnic Variations
The ethnicity of a person can be developed by changing the features while using the same basic structure.

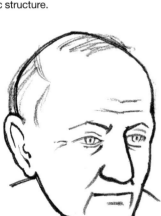

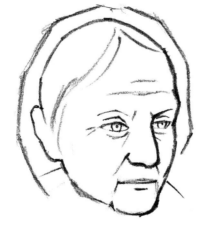

Age Variations
For an elderly man or woman, draw the ears and nose larger, the chin longer and make noticeable wrinkles.

Child's Face
The proportions of a child's face are different from those of an adult. While the eyes of an adult are placed at the middle, a child's eyes are below the middle, creating a bigger forehead. The head itself is wide and the features small.

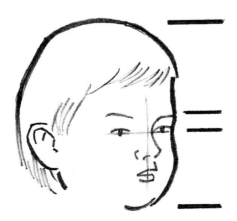

Women's Features
When drawing a woman's face, follow the same basic proportions and placement of features as used for the generic male. The ears, nose and jawline are usually smaller and more delicate, the lips larger and more noticeable. Details such as earrings, eyeliner and hairstyle can also express femininity.

5 Composition

Composition involves the arrangement of the elements in an artwork. Though composition is inherent to all art, good composition involves planning and forethought. A strong composition entertains the viewer, while a weak composition may make the viewer feel indifferent toward the artwork. A good composition is cleverly planned to lead the viewer through the scene.

Aspects of composition include symmetry, the number and placement of elements within the scene, and how the scene is framed. As you plan your composition, you will also decide on a format, create a path for the viewer's eye, and look for trouble spots.

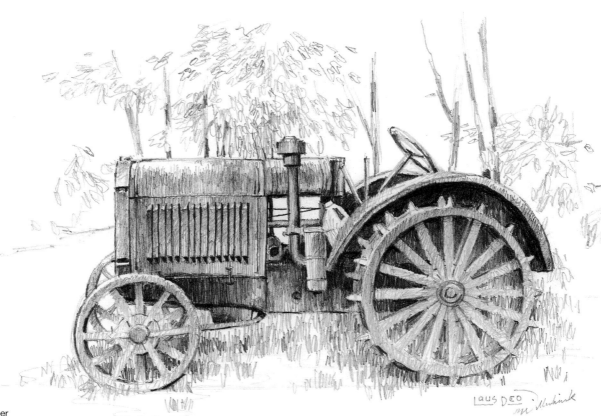

The Old Tractor
Graphite on drawing paper
11" × 14" (28cm × 36cm)

Arranging the Elements

Symmetrical composition can be useful if you want to make your subject look orderly and structured, but it often comes across as bland. *Asymmetrical* composition is preferable because it makes the objects in your drawing seem more neutral.

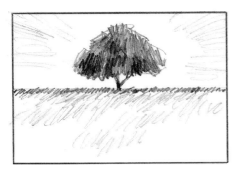

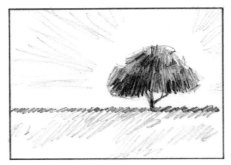

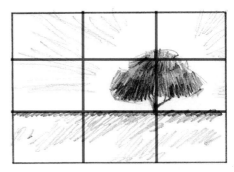

Symmetrical Composition
Though this scene is evenly balanced, it has two strikes against it: the horizontal line splits the scene exactly in half, and because the tree is placed in the middle of the composition, the scene looks contrived.

Asymmetrical Composition
Moving the tree off center makes the scene asymmetrical. The viewer should find this more appealing and realistic.

Using a Grid for Asymmetrical Composition
One method for achieving balance in an asymmetrical composition is to divide the picture into nine equal rectangles. Use the intersections of these gridlines to locate major elements in the scene.

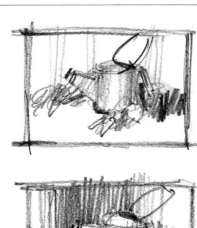

Using Thumbnail Sketches
Thumbnail sketches allow you to plan what the finished drawing will look like. Examine the differing placement of lights and darks in these examples. Can you tell which thumbnail sketch was used as a guide for the Textured Metal demonstration (page 94)?

Number of Elements

The number and placement of elements can affect the balance of the composition and by leading the viewer through the scene. An odd number is usually more interesting than an even number. Evens and odds can also refer to the number of elements reaching the edge of the artwork, which affects the way the viewer's eye travels in and out of the composition.

Even Number of Elements
An even number of elements can seem uninteresting. The viewer's eye has nowhere to go but from one fish to the other.

Odd Number of Elements
An odd number of elements is usually more interesting than an even number. This scene has an odd number of elements, with one dominant and two subordinate elements. The viewer is first drawn to the big fish, then to the smaller fish, then back to the big fish.

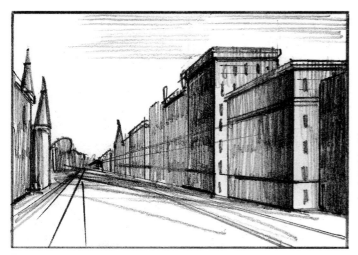

Even Number of Elements at the Edge
Evens and odds can also refer to the number of elements that reach the edge of the artwork. In this example, the buildings are touching the edge on the left and the right, making an even number.

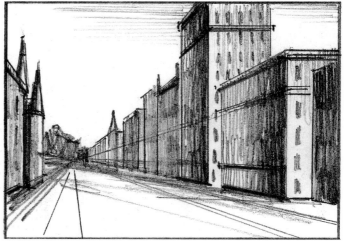

Odd Number of Elements at the Edge
A simple change allows the buildings to touch the edge on the left, right and top, creating a more interesting composition.

Cropping and Formatting

Some scenes contain too much visual information to include in a composition, and it can be hard to determine where to begin and what to leave out. By looking through a *viewfinder*, you can visually *crop* the composition before you pick up the pencil. Once you have determined the area you want to include, you will find the drawing easier to manage.

Using a Viewfinder
One method for planning a composition is to crop the scene with a viewfinder, a piece of cardboard with a cutout like a window frame. This is especially helpful when working outdoors, when the subject may seem overwhelming and you don't know where to focus your attention.

Using Your Fingers
Forming a rectangle with your fingers is another way to crop a scene without using any special equipment.

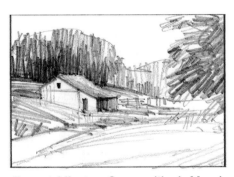

Format Affects a Composition's Mood
The mood of a picture can be accentuated by its overall shape, or *format*. A horizontal format tends to give a stable, more serene feel, while a vertical format can feel more impressive or powerful.

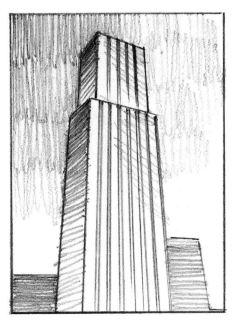

Add Diagonals to Your Subject
Diagonal lines and angled elements create a sense of action in a drawing.

Lines, Tangents and Shapes

Leading lines guide the viewer through a composition. Lines can be indicated through a pattern of elements, such as stepping stones that lead the viewer to another place in the composition. Leading lines can also guide the viewer to a *focal point*, which is the center of interest in a composition.

In art, a *tangent* is the unfortunate meeting of two or more similar lines or elements. Artists usually avoid tangents because they can make a scene confusing.

Good Use of Leading Lines
In this example we are led back to the distant mountains.

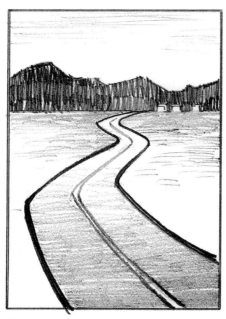

Tangents Cause Confusion
Tangents can be confusing for a viewer. This sketch has a tangent where the tree aligns with the end of the house, making it look as if the tree were part of the house.

Bad Use of Leading Lines
Not all lines lead properly. They may lead the viewer right out of the scene.

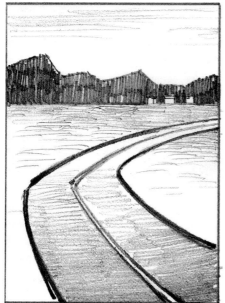

Remedying a Tangent
An easy remedy for this example is to move the tree slightly away from the corner of the house to avoid a tangent.

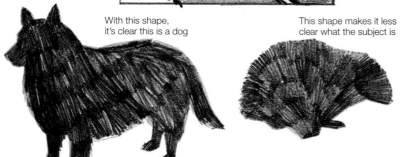

With this shape, it's clear this is a dog

This shape makes it less clear what the subject is

The Shape of Your Subject Is Important
Make your drawing experience easier by looking for subjects with an outer shape that is easy to identify. The form of a dog standing is more identifiable than the form of the same dog lying down. If you were to try to draw this dog lying down, the process of sketching and shading the dog's shape could become a bit taxing.

6 Let's **Draw**

Be patient with yourself. Good drawing skills are developed through observation and practice. Try drawing the same demo more than once and compare your results. You will probably be surprised by the level of improvement you have made.

Each demo is done in two stages. In the first stage, you'll work through structural drawing. In the second stage you'll apply values with pencil strokes. As you work through these demos, write the date in the corner of each drawing and sign it. By doing this, you will be able to see the progression of your skills in your artwork. Save your artwork, even if you are tempted to throw it away or send it through a paper shredder. Sometimes the frustration of working on a difficult lesson overshadows the improvement that has taken place. By putting your artwork aside to view later, you allow yourself the opportunity to view it with a more objective eye, when you are more likely to appreciate the skills you have developed.

Mountain Man
Graphite on drawing paper
14" × 11" (36cm × 28cm)

Still Life

A still life with fruit is always an interesting subject for interpreting forms through shading. This is a good demo for observing the play of light and shadow on common objects.

CHECK THIS OUT

Using Basic Shapes (p. 27) Light Effects (p. 52)
Gauging Proportions (p. 28)

Must-Have Materials

4H, HB, 4B graphite pencils • 11" × 14" (28cm × 36cm) medium-tooth drawing paper • Drawing board • Kneaded eraser

Optional, But Not to Be Overlooked

Dividers, proportional dividers or sewing gauge • Erasing shield • Pencil sharpener • Value scale (see page 50) • White vinyl eraser

1 Sketch the Bananas

Clip your paper to the drawing board. With a 4H pencil, sketch in the curved, oblong forms of the bananas. For accuracy, draw the full shape of the farthest banana, even though its image is partially blocked by the banana in the foreground.

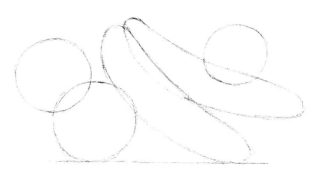

2 Sketch the Apples

Use the 4H pencil to sketch circles for the apples. To determine the placement of the foreground circle, draw a line under the foreground banana. Line up the foreground apple with the foreground banana.

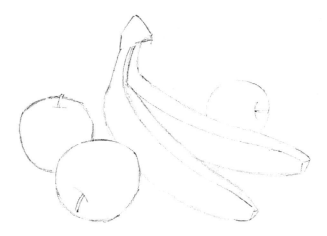

3 Define the Shapes of the Fruit

Add stems and sketch the shapes of the individual apples and bananas. You can use dividers or a gauge here to check your proportions.

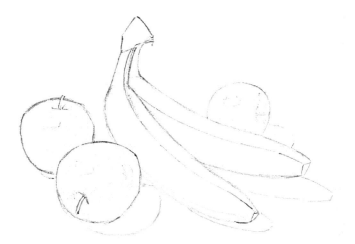

4 Add Highlights and Shadow Lines

Before using your pencil, observe the highlights and shadows. With the 4H pencil, lightly sketch where the highlights will go so you will remember to leave them white. Then sketch in where the shadows fall. Keep in mind that the primary light source is at the upper left.

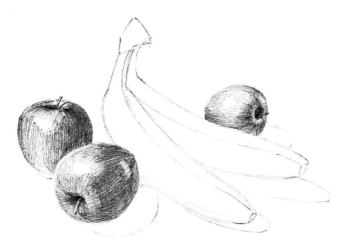

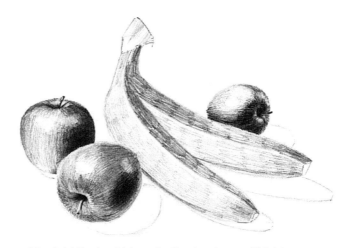

5 **Add Light Values to the Apples**
With the 4H pencil, add value and form to the apples with light lines that follow their contours. Use uniform pencil strokes to make the surfaces look smooth.

6 **Add Darker Values to the Apples and Lighter Values to the Bananas**
With the HB pencil, darken the shadow areas of the apples. With the 4H pencil, indicate the lighter values of the bananas. Check your work with the value scale.

7 **Add the Darker Values of the Bananas and Finish With Shadows and Background**
With the HB pencil, shade the darker areas of the bananas. Use a 4B pencil to add shadows under the apples and bananas, with the darkest part closest to the fruit. Add the background value with a 4H pencil, using uniform pencil strokes. Make the apples slightly darker with a 4H pencil. Use the value scale to check your work and make any necessary adjustments. Sign and date your drawing.

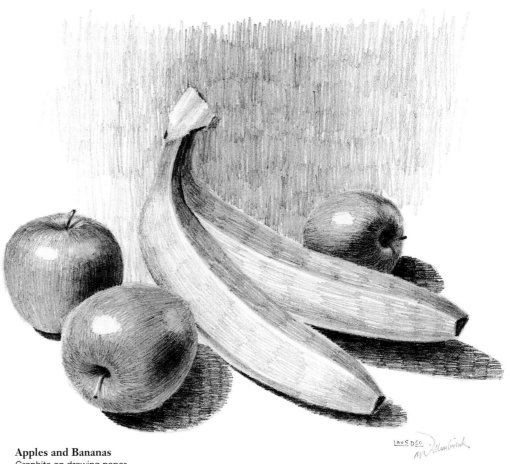

Apples and Bananas
Graphite on drawing paper
11" × 14" (28cm × 36cm)

DEMONSTRATION

Textured Metal

For this demonstration, you want a freehand look but may need the guidance of a straightedge for steps one, two and four. Make the lines you draw with a straightedge light so they won't be so noticeable with the sketchy lines used to portray a weathered watering can.

CHECK THIS OUT

Gauging Proportions (p. 28) Ellipses (p. 42)
Light Effects (p. 52) Brick, Wood & Stone (p. 58)

Must-Have Materials

4H, HB, 4B graphite pencils • 11" × 14" (28cm × 36cm) medium-tooth drawing paper • Dividers, proportional dividers or sewing gauge • Drawing board • Kneaded eraser

Optional, But Not to Be Overlooked

Erasing shield • Pencil sharpener • Value scale (see page 50) • White vinyl eraser

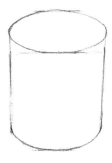 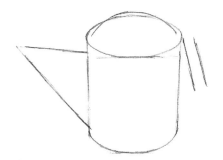 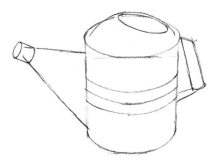

1 Draw the Cylinder of the Watering Can

With a 4H pencil, sketch a square, slightly tapered at the bottom. Draw a guideline above the square to help you place the top of the ellipse. Add height to the lines on the side, then sketch the top and bottom ellipses.

2 Add the Spout and Handle

Use the 4H pencil to sketch the lines for the spout. Use one of your proportioning tools to compare the spout width to the width of the cylinder, using this drawing as a reference. Add lines for the handle and a curved line for the top.

3 Add Details to the Watering Can

Add an angled ellipse at the top, ellipses around the central section as ribs, lines to connect the handle, and a small cylinder for the end of the spout.

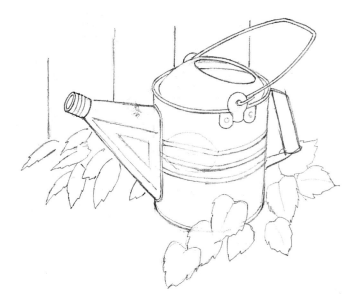

4 Add Details, Including the Leaves and Boards

Add details, including the wire handle at the top and lines where the spout attaches to the body. Create the dent by changing the shape of the lines that form the ribbing. Sketch the leaf shapes around the can and vertical lines for the boards in the background. Use a kneaded eraser to remove obsolete guidelines.

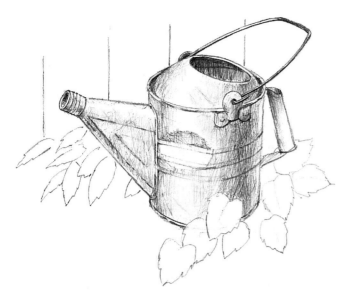

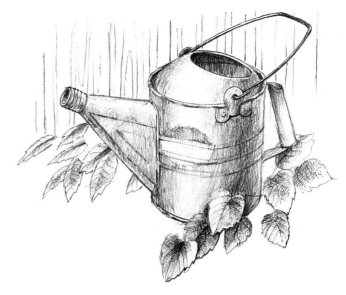

5 Add Values to the Watering Can

Add lines to indicate the structure of the leaves and boards. (See page 59 for tips on drawing wood.)

With the 4H pencil, add the shading on the watering can with thin strokes going in many directions to create a weathered texture. Because the light source is at the upper left, make the left side of the can lighter than the right side.

6 Add Texture and Value to the Leaves and Boards

Shade the leaves, using an HB pencil for the soft line work and a 4H pencil for light, thin line work. With a 4H pencil, add the appearance of wood grain to the boards.

Give Your Line Work Character

Sketch over the lines you created with a straightedge to give them a more freehand look.

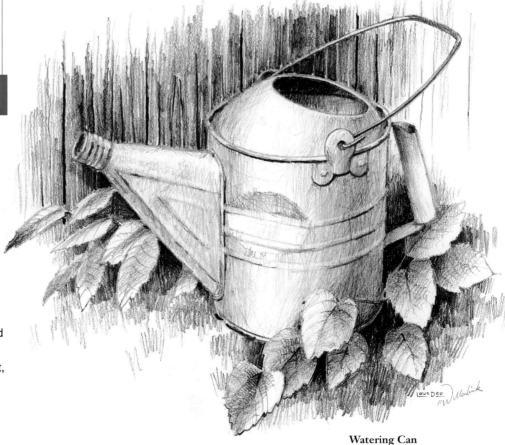

7 Add Darks and Details

Using 4H, HB and 4B pencils, add darks and details. Pinch the end of the kneaded eraser so it makes a point, and gently rub it on the paper to create lighter areas, such as the top of the ribs. Sign and date your artwork.

Watering Can
Graphite on drawing paper
11" × 14" (28cm × 36cm)

Scene in Perspective

Though it may not be obvious, this scene uses two-point per-spective, so pay attention to the subtle angles of the wall and the gate. Proportion the gate correctly by using dividers, proportional dividers or a sewing gauge to compare the width of the gate's opening to the opening's height.

CHECK THIS OUT

Gauging Proportions (p. 28) Rocks (p. 60)
Two-Point Perspective (p. 36)

Must-Have Materials

4H, HB, 4B graphite pencils • 11" × 14" (28cm × 36cm) medium-tooth drawing paper • Dividers, proportional dividers or sewing gauge • Drawing board • Kneaded eraser • Value scale (see page 50)

Optional, But Not to Be Overlooked

Erasing shield • Pencil sharpener • White vinyl eraser

1 Sketch the Basic Lines of the Walk and Gate

Start by sketching the stone walk and the opening for the gate using a 4H pencil. Use your proportioning skills and tools to make sure the proportions are correct.

2 Add the Foliage

Lightly sketch the outer shapes of the foliage with a 4H pencil.

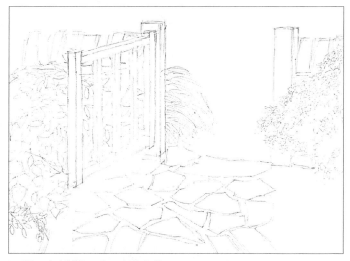

3 Add Structural Details

Sketch the details of the gate, foliage and stones. Erase any unnecessary guidelines with a kneaded eraser.

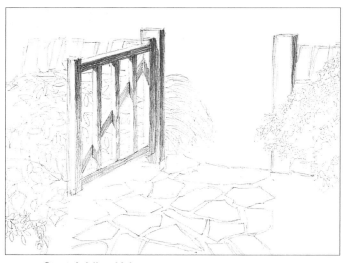

4 Start Adding Values

With your value scale as a reference for the rest of this demo, use a 4H pencil to add values to the gate. Direct your pencil lines to follow the grain of the wood. Make the values of the shadowed side of the gate gradate from dark at the top to light toward the bottom.

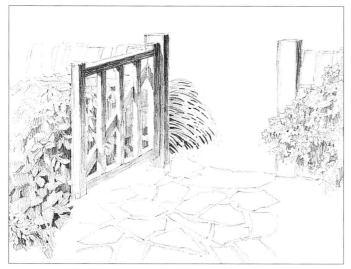

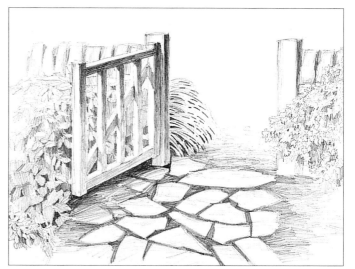

5 Add Values to the Foliage

With a 4H pencil, add values to the foliage. Draw the various types of leaves differently from one another, using differing values and line strokes. Make the shadows behind the leaves darker than the leaves themselves.

6 Add Values to the Ground and Stones

Add values to the stonework and to the ground around and between the stones with a 4H pencil. (See page 58 for tips on creating the texture of stone.)

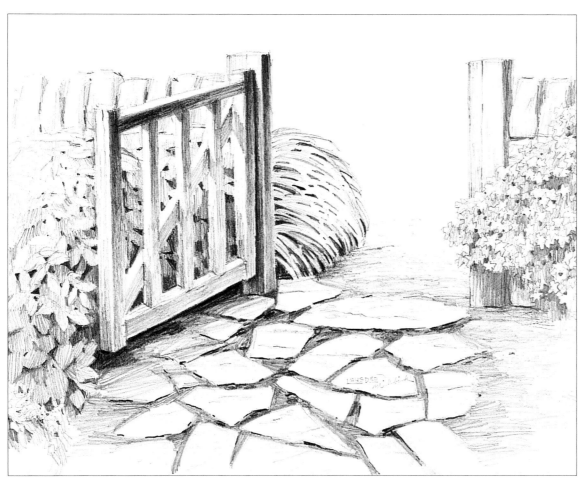

7 Finish With Details and Darks

Add the finishing details and additional darks using 4H, HB and 4B pencils. Check the range of your values with your value scale and darken areas as needed. Sign and date your drawing.

Garden Gate
Graphite on drawing paper
11" × 14" (28cm × 36cm)

Natural Textures

This fun drawing explores different textures, such as tree bark and fur. This is another drawing that could easily be made into a greeting card. It could also be framed and given to your favorite niece or nephew.

CHECK THIS OUT

Using the Basic Shapes (p. 27) Creating Values (p. 51)
Gauging Proportions (p. 28)

Must-Have Materials

4H, HB, 4B graphite pencils • 11" × 14" (28cm × 36cm) medium-tooth drawing paper • Drawing board • Kneaded eraser

Optional, But Not to Be Overlooked

Dividers, proportional dividers or sewing gauge • Pencil sharpener • Value scale (see page 50) • White vinyl eraser

1 Sketch the Faces

Observe the basic shapes that make up the raccoons' faces before beginning. Using a 4H pencil, sketch ovals to represent the outlines of the raccoon's faces. Sketch vertical lines for the centers of their faces and horizontal lines for the placement of their eyes, which are below the middles of the ovals. Next, draw small ovals for the snouts.

2 Continue Refining the Faces and Indicate the Tree

Add shapes representing the eyes, ears and noses. Draw the hole, trunk and small oval for the paw.

3 Erase Extra Lines

Erase guidelines with a kneaded or white vinyl eraser before continuing with your drawing.

4 Add Details to the Raccoons

Add lines to indicate important details, including guidelines to indicate the markings on the raccoons' faces, the the paw and the tree bark.

5 **Begin Adding Values**
Still using a 4H pencil, begin adding the lighter values to the raccoons and the tree.

6 **Add Dark Values**
Now, using a 4B pencil, add the dark values. Keep small highlights in the eyes to suggest their glossiness.

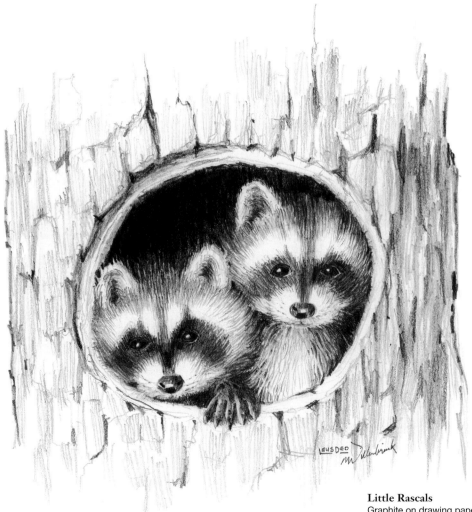

7 **Add Middle Values and Finishing Details**
Add fur and finishing details with an HB pencil, checking the range of your values with the value scale. Lighten or darken areas as needed. Sign and date your drawing.

Little Rascals
Graphite on drawing paper
11" × 14" (28cm × 36cm)

Using Contrast

This demo shows how to rely more on value contrasts than on pencil outlines to define shapes. The light source in this scene is at the top right, but the snow also reflects light, making the wolf's outline light as well. This looks dramatic against the dark of the mountains. When collecting your supplies, include your value scale and proportioning devices so they will be handy when you need them.

CHECK THIS OUT

Using Basic Shapes (p. 27) Creating Values (p. 51)
Gauging Proportions (p. 28) Lines, Tangents & Shapes (p. 90)
Contrast (p. 49)

Must-Have Materials

4H, HB, 4B graphite pencils • 14" × 11" (36cm × 28cm) medium-tooth drawing paper • Copier paper to be used as a friskett • Dividers, proportional dividers or sewing gauge • Drawing board • Kneaded eraser • Value scale (see page 50) • White vinyl eraser

Optional, But Not to Be Overlooked

Erasing shield • Pencil sharpener • Scissors • Straightedge, triangle or angle ruler

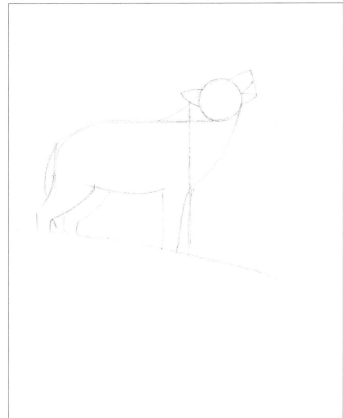

1 Draw the Basic Shapes

Using a 4H pencil, sketch the basic shape of the body and the slope of the hillside. Add a circle for the basic shape of the head. While you may be tempted to rush on to the next step, this is the time to pay attention to proportions so the finished drawing will be accurate. Use a proportioning device to check your work, making adjustments as necessary.

2 Sketch the Overall Shape of the Body

With the 4H pencil, sketch the shape of the body, including the legs, neck, ear, mouth, lower jaw and tail. Pay close attention to the placement of the line for the belly because this will affect how tall the legs appear. Check your work with a proportioning device and make adjustments as needed.

3 **Add Detail Lines to the Wolf
and Sketch the Mountains**
Erase obsolete guidelines with your white vinyl eraser and add details to the face, including the eye and nose, with the 4H pencil. Suggest the texture of the coat with back-and-forth lines along the outline of the body and within the body itself. Sketch in the mountains. Pay attention to where the lines of the wolf meet the lines of the mountains, making sure you do not create unwanted tangents (see page 90).

4 **Start Adding Values**
With a 4H pencil, add shading to the wolf, letting your pencil strokes follow the direction of the fur. With the exception of the head, keep the outer edges of the wolf light to suggest the light from the sky and the light reflected off the snow. This is a good place to start referring to your value scale as you lay down lights and darks for the rest of this demo.

5 Add Darks and Details to the Wolf

With the HB pencil, add the darker values to the coat and the shadow areas. Add facial details by darkening the eye, nose and mouth, leaving white spaces to indicate teeth. Add dots to the wolf's muzzle to suggest whiskers.

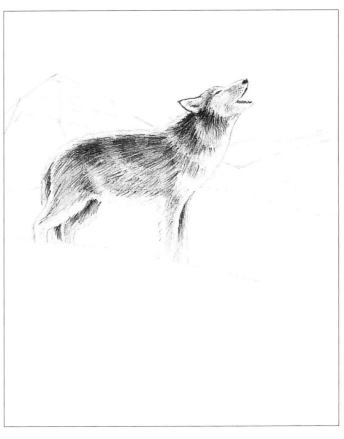

6 Add Lighter Values to the Distant Mountains

Using the 4H pencil, make back-and-forth strokes, filling in the mountains except for the area in direct sunlight.

7 Add the Darks of the Trees
With the HB pencil, indicate the exposed rock of the mountains with short back-and-forth strokes.

8 Add the Dark Background Trees
With a 4B pencil, use vertical pencil strokes to add the dark areas of the background trees. To do this, cut a piece of copier paper in the same curve as the hillside. Use this as a frisket to create a clean edge, as discussed on page 15.

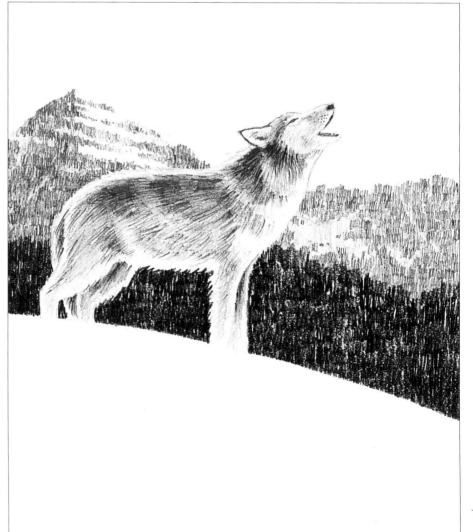

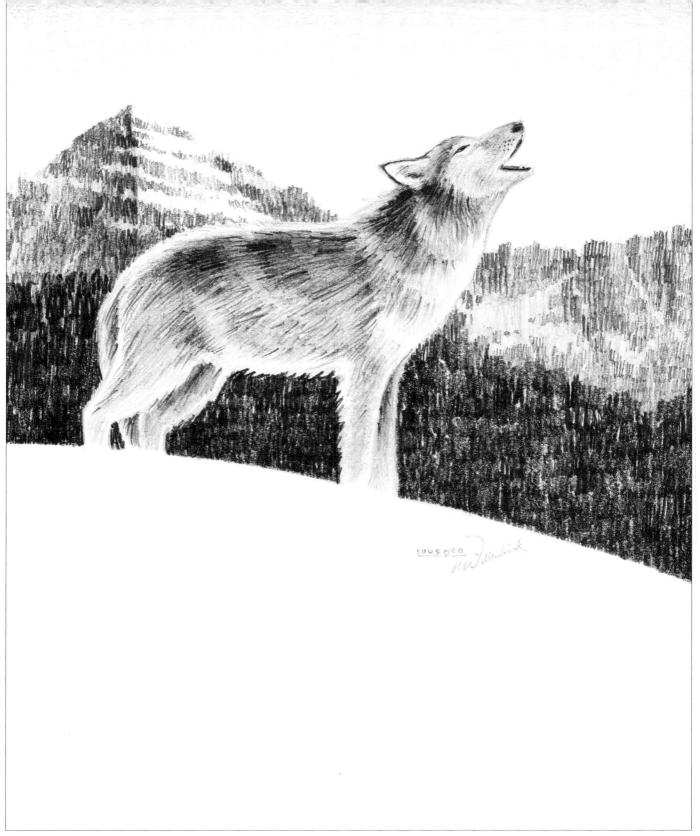

Add Finishing Touches

9 Now to step back from your drawing to observe the range of lights and darks in the sky. Before you attempt to add the sky, consider practicing this step on a piece of scrap paper. Using a 4H pencil, add light values to the sky with long, horizontal lines. Start with light pressure at the top and gradually decrease the pressure as you work down. If you get frustrated, leave the sky white; your drawing will still be dramatic. Be encouraged. You can come back and try this again at a later date for better results. Either way, sign and date your drawing.

Call of the Wild
Graphite on drawing paper
14" × 11" (36cm × 28cm)

Expressive Portrait

Good art begins with an interesting subject. Be on the lookout for inspiring subjects because your best art will no doubt come from this inspiration. For portraits, sketch the facial structure first. Look into a mirror and use your own features as a guide. This will help you place elements such as the hat and beard with less guesswork. Apply line work in a rough and irregular manner to complement the rugged appearance of the subject.

CHECK THIS OUT

Gauging Proportions (p. 28) Face: Front View (p. 82)
Human Figures (p. 78)

Must-Have Materials

4H, HB, 4B graphite pencils • 14" × 11" (36cm × 28cm) medium-tooth drawing paper • Drawing board • Kneaded eraser

Optional, But Not to Be Overlooked

Dividers, proportional dividers or sewing gauge • Pencil sharpener • Small mirror • Value scale (see page 50) • White vinyl eraser

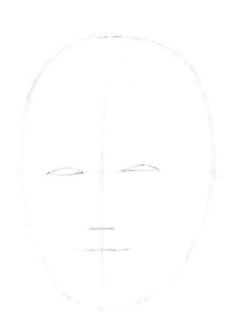

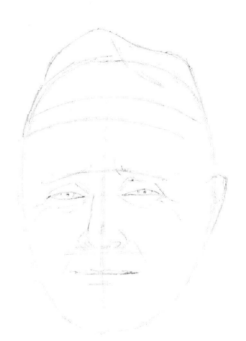

1 Sketch the Face
With a 4H pencil, sketch the overall shape of the head and lines for the eyes and center of the face. The head is viewed slightly from the side, making the center line of the face somewhat left of center. Sketch in lines for the mouth and nose. Add the eyes.

2 Sketch Facial Features and the Top of the Hat
Sketch facial features, including the eyebrows, ears, nose, lips, pupils, irises and creases around the eyes, using the 4H pencil. Now is the time to adjust the facial features, if necessary. I decided to make the nose shorter from what I originally sketched. Add the top of the hat and band. Notice that much of its form follows the shape of the head. Add a curved line to indicate the major fold of the hat.

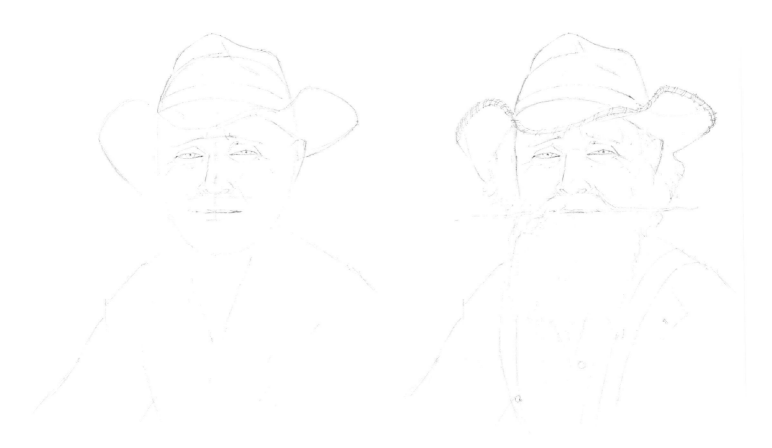

3 **Add the Brim, Shoulders and Arms**
Using the 4H pencil, add the brim. Notice the sides are turned up. Add lines to indicate the arms and shoulders.

4 **Add the Hair, Beard and Details**
Sketch in the basic form of the hair, beard and mustache. Add details throughout the drawing, erasing the obsolete guidelines in the process with a kneaded eraser. Make minor adjustments to the hat, if necessary.

Use a Small Mirror
Consider looking in a mirror throughout this demo to observe your own features so you will better understand the structure and values of the face.

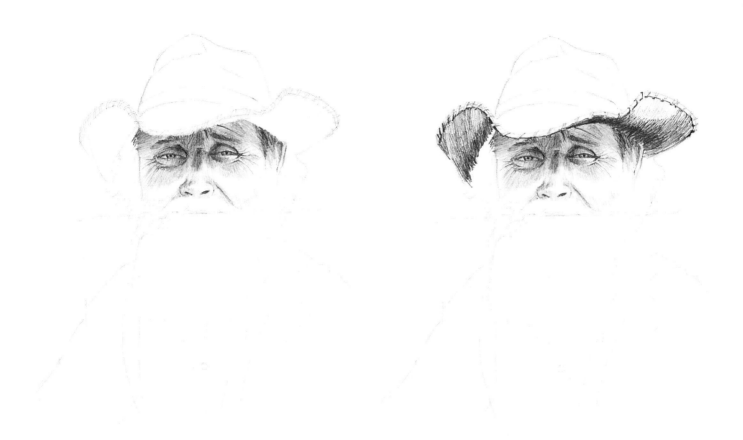

5 Add Values to the Face

With the 4H pencil, add values to the face. Pay particular attention to the eyes; they are the soul of a portrait. Continue adding values to the face using the HB pencil for the darker places such as the creases near the eyes, the eyebrows and the nostrils. Leave the lightest areas on the cheeks completely white as highlights.

6 Shade the Underside of the Hat

Now add values to the underside of the hat brim. Use back-and-forth strokes to indicate the shape of the hat's underside. Use a 4H pencil for the light areas and an HB pencil for the dark, shadowy areas near the face.

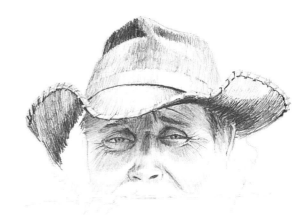

7 Add Details to the Top Portion of the Hat

Use a 4H pencil to add values to the top part of the hat. Add fewer lines for the lighter areas. Use the HB pencil for the darker shadow areas under the band and for the very top fold of the hat.

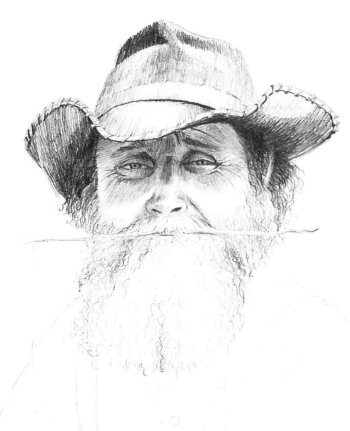

8 Add Details to the Hair and Beard

With lots of squiggly lines, draw in the hair and beard using 4H and HB pencils. Notice that the lighter areas have fewer lines.

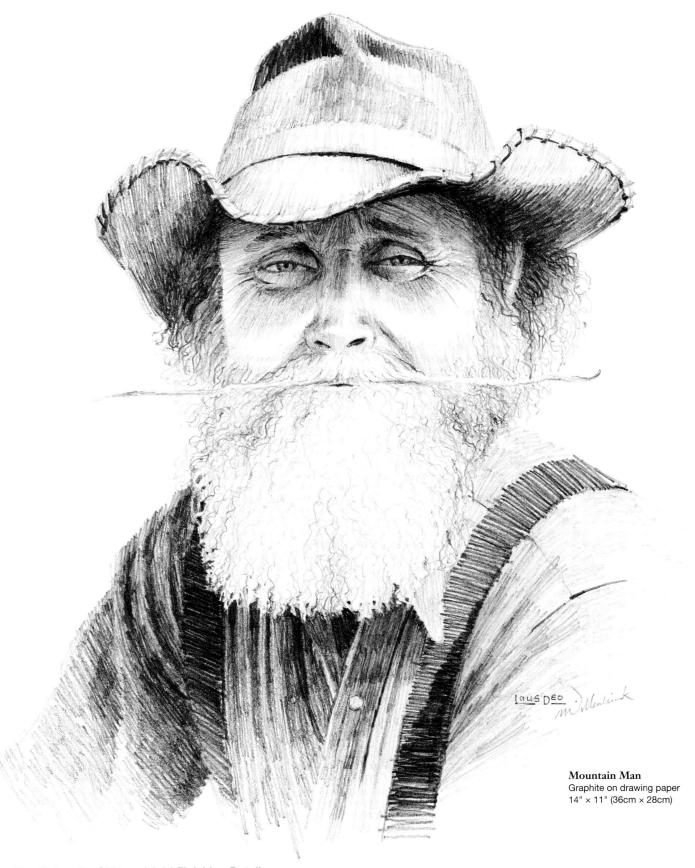

Mountain Man
Graphite on drawing paper
14" × 11" (36cm × 28cm)

9 Refine the Shirt and Add Finishing Details

Add the shirt and suspenders with a 4H pencil for the lighter areas, an HB pencil for the darker areas. If you feel that you drew the shoulders too low, add more to them along the top. Add additional darks and details. Sign and date your drawing.

Telling a Story Through a Drawing

This is a great demo for learning more about how to draw people. Clothing and props can tell a story to add interest to a drawing.

CHECK THIS OUT

Using a Frisket (p. 15)
Gauging Proportions (p. 28)
Human Figures (p. 78)

Face: ¾ View (p. 83)

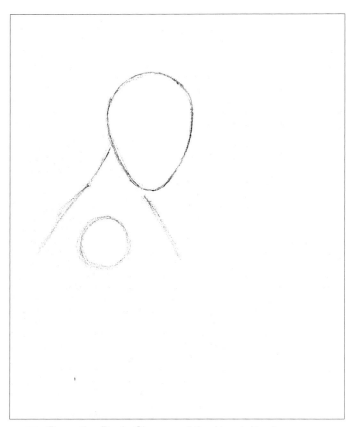

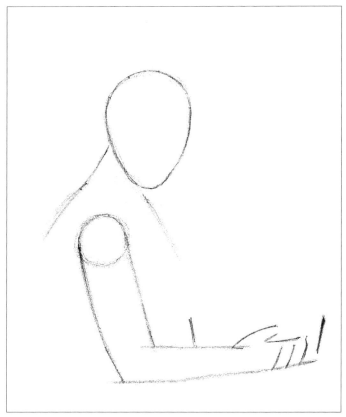

1 Draw the Basic Shapes of the Head, Neck and Shoulder

With a 4H pencil, sketch an egg-shape for the head, in three-quarters view. Sketch the neck and shoulders. Add a circle indicating the shoulder joint. Check your proportions with one of the proportioning tools.

2 Add the Arm and Hand

Add lines for the upper and lower forearm. For correct proportions, compare the length of the upper and lower arm to the height of the head, using one of the proportioning tools. Sketch lines for the hand and basket. Add lines that indicate the ridges of the hand's knuckles and thumb. At this stage, the hand should look like a mitten, since the individual fingers are not yet defined. Sketch lines to indicate the sides and bottom of the basket.

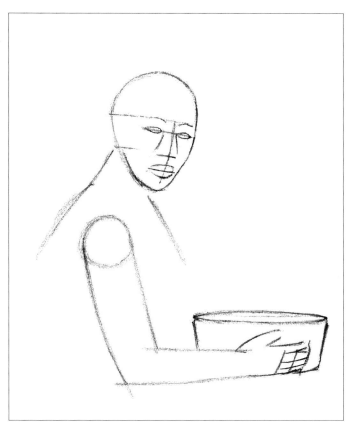

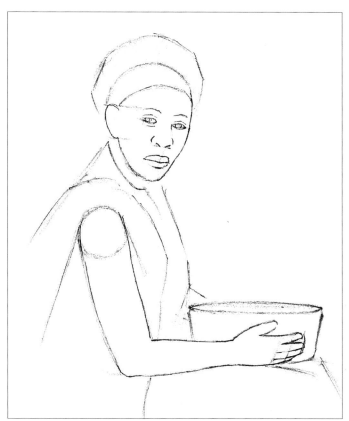

3 Sketch the Features and Fingers

Sketch in placement lines for the eyes and nose, and add a line for the center of the face. Sketch ellipses for the basket. Then go back and refine the eyes, nose, mouth and eyebrows. Add the individual fingers on the hand. To see which fingers are longer and shorter, you may want to look at your own hand and draw accordingly.

4 Continue Defining the Face, Hand and Arm and Indicate the Clothing

Sketch the ear and add more definition to the facial features, arm, hand and fingers. Erase any obsolete guidelines with a kneaded or white vinyl eraser. Add the basic form of the clothing and head scarf, noting where major folds occur. Also add short lines indicating the arm on the far side of the basket.

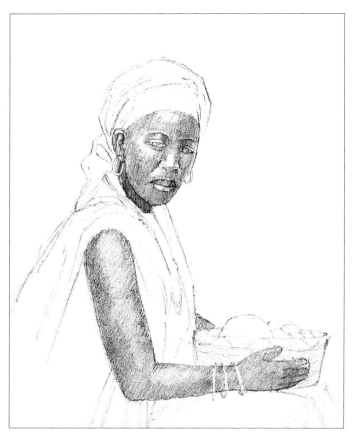

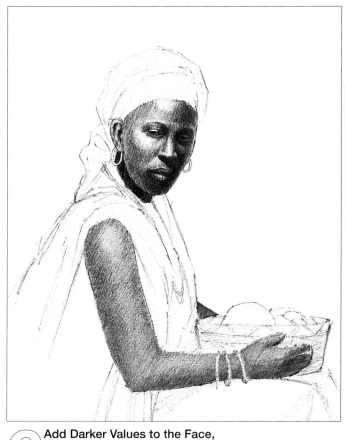

5 **Add Details and Begin Shading**
Sketch in the vegetables, the weave of the basket and the jewelry. Add details to the clothing, basket and ear. Erase any obsolete guidelines with a kneaded or white vinyl eraser. Add very light lines to indicate value variations on the face, neck and arm. Use the value scale to check the appropriate value changes. Keep in mind that the light source is at the upper left, so shade accordingly. Lighten some of the pencil work on the forehead, cheek, nose and arm by gently pressing a kneaded eraser on these areas to lift some of the graphite.

6 **Add Darker Values to the Face, Neck, Arms and Hands**
With an HB pencil, darken the neck, the far side of the face and under the nose and lips. Define the eyes and ear, darkening any area in shadow. Darken the arms and hand, making the farthest arm darker than the nearest arm. Use the value scale to check the values. Add a few details to the fingers, but keep the details to a minimum as the fingers are mostly in shadow.

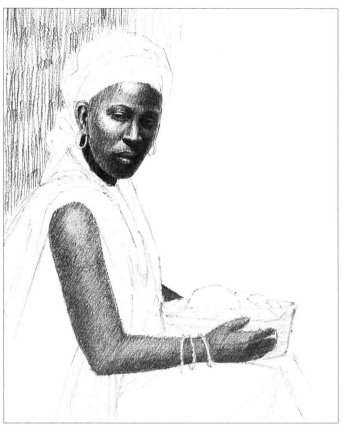

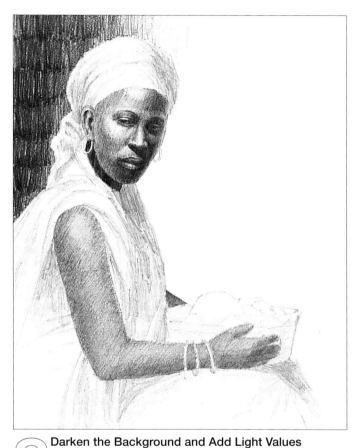

7 Add the Background

With the HB pencil, begin adding the darks of the background. Use the value scale to create the appropriate level of lights and darks. Confine your marks to the top and left sides of the background. To make a clean edge, use copier paper as a frisket and proceed with downward pencil strokes. After you've done some of the background with the frisket, remove it and continue putting in the background without the frisket, giving the border a rough, loose look.

8 Darken the Background and Add Light Values to the Clothing

Use the HB pencil to make up-and-down strokes to further darken the values of the background. With the 4H pencil, add the lighter values to the clothing. Add interest to the composition by continuing the clothing on the left beyond where the dark of the background ends.

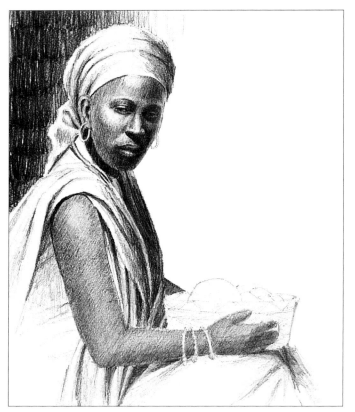

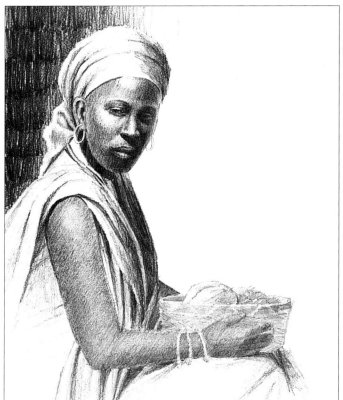

9 Add Darks to the Clothing

With an HB pencil, add the darks to the clothing. Use the value scale to help you add the appropriate values. The creases of the clothing will most likely be very dark.

10 Add Light Values to the Basket and Vegetables

With a 4H pencil, start adding values to the basket, keeping some areas light to show the weave. Use subtle value changes for the vegetables, with the lightest areas on the left.

11 Add Darks to the Basket and Vegetables and Add the Finishing Details

With the HB pencil, add darker values to the basket and vegetables. Use the value scale to see if you need to make any adjustments with the 4H and HB pencils. Make some areas, such as some of the clothing creases, even darker using a 4B pencil. Lighten any areas that are too dark by gently removing the graphite with the kneaded eraser. Sign and date your drawing.

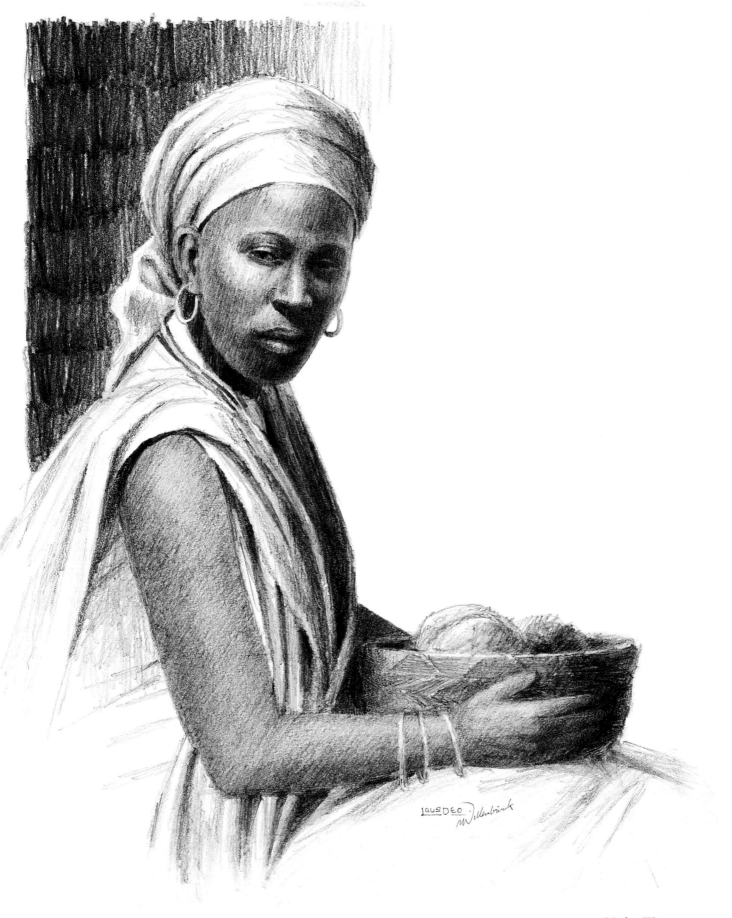

Market Woman
Graphite on drawing paper
14" × 11" (36cm × 28cm)

Landscape Composition

To a beginner, full compositions can seem overwhelming. Just remember, most elaborate drawings are just a grouping of smaller drawings. This particular drawing is made up of three main subjects: the building, the tree left of the building and the sheep. Approach it with the idea that each is a separate drawing that contributes to the whole. Take your time, be patient with yourself and enjoy the process.

CHECK THIS OUT

Must-Have Materials

4H, HB, 4B graphite pencils • 14" × 11" (36cm × 28cm) medium-tooth drawing paper • Drawing board • Kneaded eraser • Straightedge, triangle or angle ruler • Value scale (see page 50)

Optional, But Not to Be Overlooked

Dividers, proportional dividers or sewing gauge • Pencil sharpener • White vinyl eraser

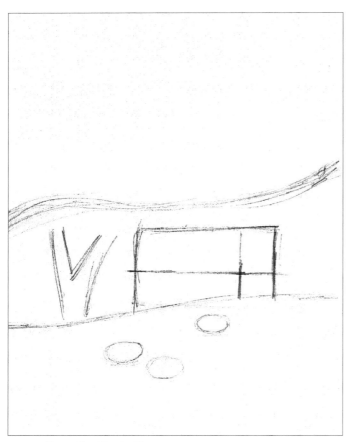

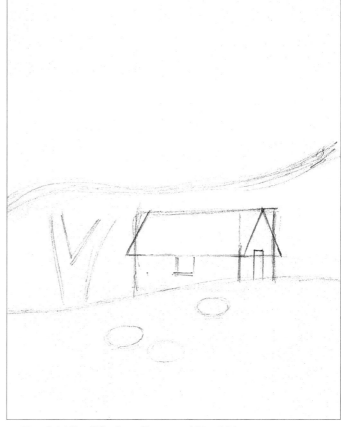

1 Draw the Basic Shapes
With a 4H pencil, lightly sketch a rectangle for the basic shape of the springhouse, then add a line for the roof's edge and another line for the front corner of the house. This may be a good time to get out your straightedge to help you draw accurate lines. Sketch the grass line, tree trunk, leaf canopy and ovals for the sheeps' bodies.

2 Add the Window, Door and Roof Lines
Using the 4H pencil and your straightedge, add the window and door to the springhouse along with angles to the roof. You may want to use an angle ruler to check your angles.

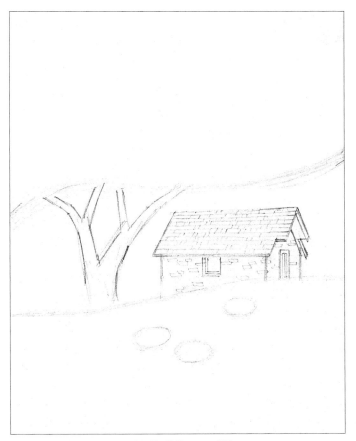

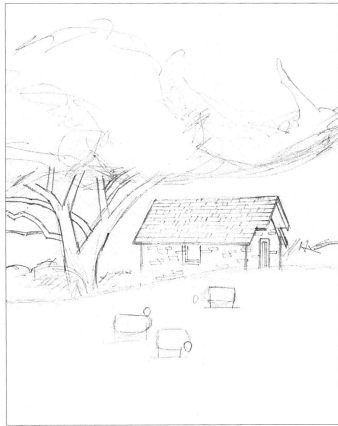

3 Add Details to the Building and Tree

With the 4H pencil, add more lines to define the spring-house, including additional overhang to the right side. Erase any unnecessary guidelines with a kneaded eraser. Sketch in more of the tree's structure, tapering the smaller branches that grow away from the trunk.

4 Add Definition to the Trees, Foliage and Sheep

With a 4H pencil, add more branches. Sketch the basic shapes of the tree's foliage and the bushes and shrubs along the house. Sketch the heads and legs of the sheep.

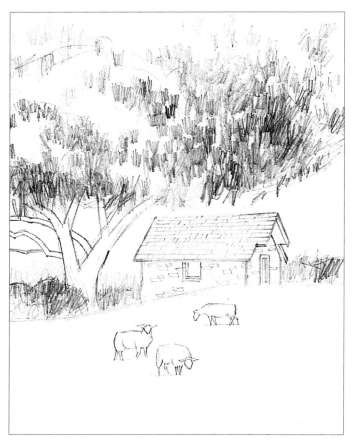

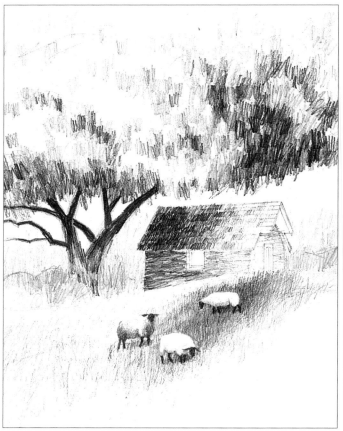

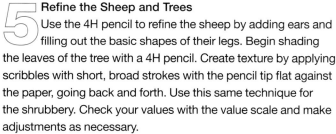

5 Refine the Sheep and Trees
Use the 4H pencil to refine the sheep by adding ears and filling out the basic shapes of their legs. Begin shading the leaves of the tree with a 4H pencil. Create texture by applying scribbles with short, broad strokes with the pencil tip flat against the paper, going back and forth. Use this same technique for the shrubbery. Check your values with the value scale and make adjustments as necessary.

6 Add Shading and Grass
Add shading to the springhouse, sheep and foliage. Use the 4H pencil for the lighter shading and the HB pencil for the darker shading. Notice that the springhouse is darker on the left side because it is in shadow.

With 4H and HB pencils, add grass to the foreground and shade the sheep further. Make the body of the sheep on the far left dark and keep the grass around it light for contrast. The bodies of the other two sheep are light, so make the grass around them darker with an HB pencil. By doing this, you won't have to rely on outlines to define the sheep; instead they are defined by contrast. Check your work with the value scale.

7 Add the Darkest Darks and Finishing Details
Make any adjustments to the shading and details with the 4H and HB pencils. Use the 4B pencil for the darkest darks, such as the window and door openings and shadow areas of the tree. Check the range of your lights and darks with your value scale and make any necessary changes. Sign and date your drawing.

Springhouse
Graphite on drawing paper
14" × 11" (36cm × 28cm)

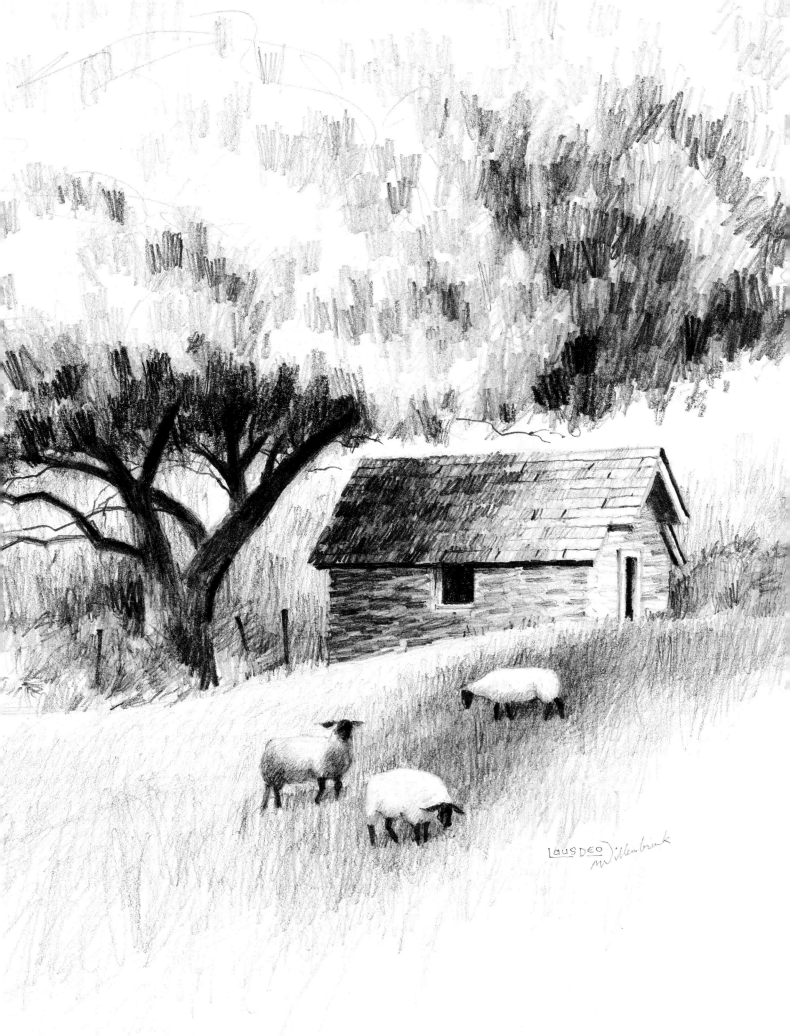

Seascape Composition

Approach this drawing by first establishing the most difficult element to draw, the foreground boat, then work back in the distance. When shading in an area, let your line strokes follow the direction of the material you're trying to create, such as the woodgrain of the boards.

CHECK THIS OUT

Must-Have Materials

4H, HB, 4B graphite pencils • 11" × 14" (28cm × 36cm) medium-tooth drawing paper • Drawing board • Kneaded eraser • Straightedge, triangle or angle ruler

Optional, But Not to Be Overlooked

Dividers, proportional dividers or sewing gauge • Pencil sharpener • Value scale (see page 50) • White vinyl eraser

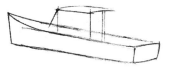

1 Sketch the Foreground Boat

With a 4H pencil, sketch the basic lines for the foreground boat. Add the curved lines of the hull and the lines of the back, or stern, of the boat. With a straightedge to guide you, sketch the side of the cabin, add the roof and the pole that supports the roof.

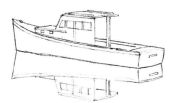

2 Add Details to the Boat

Add the structural features of the boat. Erase obsolete guidelines with a kneaded or white vinyl eraser. Follow this procedure to add the reflection of the boat.

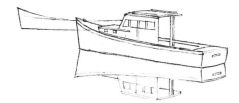

3 Add the Basic Structure of the Second Boat

Sketch the second boat with the 4H pencil. This boat is viewed straight on, so the use perspective is minimal.

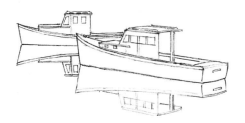

4 Add Details to the Second Boat

Sketch in the structure of the cabin. Add the reflection of the boat, and erase obsolete guidelines.

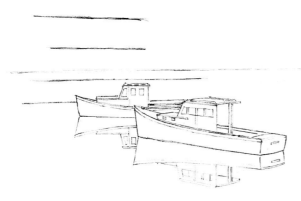

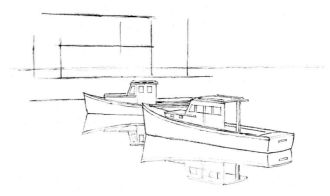

5 Sketch the Horizon and Begin the Building
You may want to use your straightedge for the following steps. Use the 4H pencil to add the horizon line, then add the horizontal lines of the building. Notice that they would converge at a vanishing point far on the distant right.

6 Add the Vertical Lines of the Building
With the 4H pencil and a straightedge, sketch the vertical lines of the building. Pay attention to their proportions and placement.

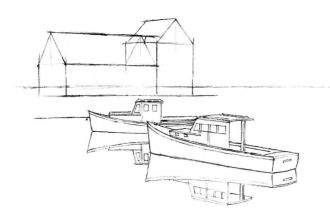

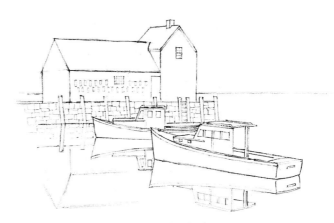

7 Form the Roofs and Gables
Add the roofs and gables with the 4H pencil and a straightedge. Some of the lines, such as the one coming from the tallest roof peak, will go toward a vanishing point on the left side.

8 Add Details to the Building's Structure
With the 4H pencil, add details to the building, including windows, door and trim and the poles and stones to the pier. You may want to check your angles with an angle ruler. Erase any obsolete guidelines.

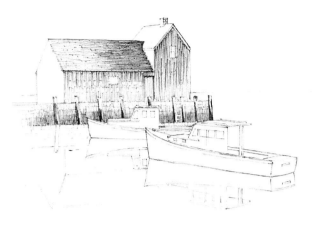

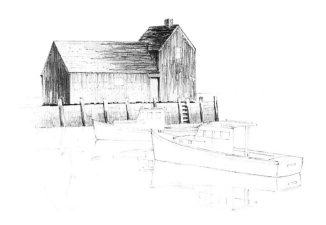

9 **Start Shading the Building and Stonework**
Start shading the lighter side of the building and the stonework with a 4H pencil, remembering that the light source is at the upper right. Darken the stonework near the water line. Use the value scale to check your values as you work through the rest of these steps.

10 **Add the Darker Values to the Building and Stonework**
Add the darker values to the roof, the chimney and the darker sides of the building with 4H and HB pencils. Use the HB pencil for the darker areas, such as adding shadows under the building.

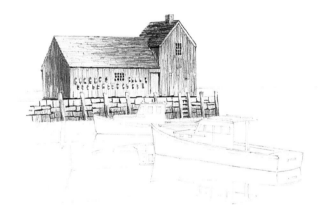

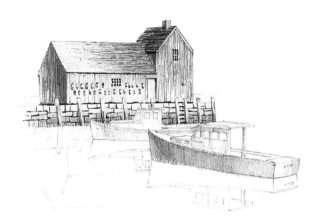

11 **Continue Adding Darks to the Building and Stonework**
Continue adding more darks and details to the building and stonework with 4H and HB pencils, as necessary. Apply the darkest darks with the 4B pencil.

12 **Start Adding Values to the Boats**
Add the lighter values of the boats with a 4H pencil. Make the foreground boat darker than the second boat for contrast.

Add Middle Values to the Boats
Add the middle values of the boats with the HB pencil. Clean up any smudges and erase any unnecessary lines with a kneaded eraser.

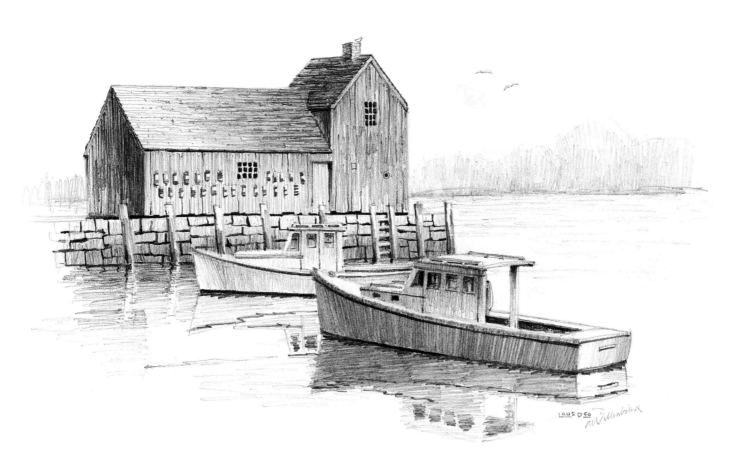

Add Reflections and Final Darks and Details
Add reflections with back-and-forth horizontal strokes using a 4H pencil. Lightly indicate distant water and trees near the horizon. Add some darks to the boats with a 4B pencil and darken much of the foreground boat with the 4H pencil. Add some simple seagull shapes with a 4H pencil. Sign and date your artwork.

Rockport Harbor
Graphite on drawing paper
11" × 14" (28cm × 36cm)

Glossary

Acid-free paper. Paper that has not been processed with acid. Acid can cause paper to yellow over time.

Angle ruler. A small ruler that can fold in the middle to measure angles.

Asymmetrical. That which is not symmetrical. In reference to art, something may be balanced without being symmetrical.

Atmospheric perspective. The illusion of depth achieved through contrasts in value and definition.

Baseline. A line that establishes the placement of a subject and helps you work out the proportions of a drawing.

Blind contour sketch. A sketch or drawing done with a single line without looking at the paper.

Cast shadow. The shadow of an object that appears on a different surface or object.

Chiaroscuro. A sketch or drawing that defines the form of an object using only highly contrasting values, usually black and white, instead of with contour lines or shading.

Composition. The arrangement of elements in an artwork.

Contour sketch (or Continuous line sketch). A sketch or drawing that is done with a single line.

Contrast. Differences between the values in a composition.

Craft knife. A small knife with a sharp, pointed, replaceable blade.

Crop. Determine the area of a scene to be included within an artwork.

Dividers. A handheld compasslike device for measuring and proportioning.

Drawing. A finished representation of a subject.

Drawing board. A smooth, sturdy board placed underneath the paper for sketching or drawing.

Drawing paper. Heavyweight paper, commonly 80 lb. to 90 lb. (170gsm to 190gsm), used for drawing.

Ellipse. The shape a circle takes on when viewed at an angle. Used to show perspective.

Erasing shield. A thin metal shield used to mask areas that are not to be erased.

Eye level. *See* Vantage point.

Fixative. A spray applied to pencil drawings to prevent the artwork from smudging.

Focal point. The area or part of a painting to which the composition leads the eye, also referred to as the center of interest.

Form shadow. A shadow on an object that gives the form more dimension.

Format. The overall shape of a composition.

Frisket. A sheet of paper used as a shield to create an even edge or a clean margin beside a set of pencil lines.

Gauge. To determine specific proportions of elements in a scene.

Graphite. A soft black substance used in the core of some pencils.

Highlight. An area of light on an object, usually placed in the direct path of the light.

Horizon line. The line where land or water meets the sky, in reference to linear perspective.

Kneaded eraser. A soft, pliable gray eraser.

Lead. The term mistakenly used for graphite in a pencil. Also the scale that rates the hardness or softness of the graphite.

Leading lines. A group of compositional elements used to form lines to direct the viewer's eye to centers of interest.

Light box. A device that shines light evenly through a translucent surface. This allows the viewer to see slides, transparencies or drawings laid on its surface.

Light source. The origin of the light shining on elements in a composition.

Linear perspective. Depth implied through line and the relative size of elements in a composition.

Mechanical pencil. A pencil consisting of a thin stick of graphite encased by a holder similar to a pen. Mechanical pencils need no sharpening.

One-point perspective. A type of linear perspective with one vanishing point.

Pad. A stack of sheets of paper attached at one side with glue or wire.

Paper weight. The thickness of a sheet of paper; common weights for sketch paper are 50 lb. to 70 lb. (105gsm to 150gsm). For drawing paper common weights are 80lb to 90lb (170gsm to 190gsm).

Pencil extender. A device that attaches to the end of a pencil that has been shortened by use, used to extend the pencil's life.

Pencil sharpener. A mechanical device used to sharpen the ends of pencils.

Perspective. A technique that gives the illusion of depth to a flat picture.

Proportional dividers. Dividers that have points at both ends and are used for proportionally enlarging or reducing a hand-drawn image.

Reference materials. Pictures from various sources, used to examine a subject more closely, or from different angles, or under different conditions.

Reflected light. Light reflected off one surface onto another.

Sandpaper pad. A very small pad of sandpaper sheets attached to a handle; used for sharpening pencil tips.

Sewing gauge. A hand-held device with a moveable marking guide that can be used for measuring proportions.

Sketch. A drawing in rough, unfinished form.

Sketch paper. Lightweight paper, commonly 50 lb. to 70 lb. (105gsm to 150gsm), used for sketching.

Slip sheet. A sheet of paper placed over an unfinished drawing, under the drawing hand, to prevent the hand from smearing the graphite as it moves across the paper.

Straightedge. A metal ruler or similar tool used for drawing straight lines.

Structural sketch. The primary line work that the values (lights and darks) and line work of a drawing are built upon.

Symmetrical. Balanced composition, with equal elements placed as if reflected in a mirror.

Tangent. The unfortuante meeting of two similar compositional elements. Tangents usually detract from a composition because they can confuse the viewer.

Three-point perspective. A type of linear perspective with three vanishing points—two at the vantage point and one either above or below eye level.

Thumbnail sketch. A small, quick sketch.

Tooth. The roughness of a paper surface.

Tracing paper. Thin, translucent paper used in the process of drawing.

Triangle. A thin, transparent triangle formed out of plastic used for drawing lines.

T-square. A straightedge with a perpendicular attachment that allows the tool to glide along the side edge of a drawing board or paper pad.

Two-point perspective. A type of linear perspective with two vanishing points.

Values. Degrees of light and darkness in a sketch or drawing.

Value scale. A scale showing a range of values.

Value sketch. A thumbnail sketch used to plan the lights and darks of a drawing.

Vanishing point. A point usually on the horizon line, at which parallel lines seem to converge.

Vantage point. The point from which the viewer observes a scene.

Viewfinder. A device used to crop a scene.

White vinyl eraser. A white, squarish eraser.

Index

Ideas. Instruction. Inspiration.

Receive FREE downloadable bonus materials when you sign up for our free newsletter at artistsnetwork.com/Newsletter_Thanks.

Find the latest issues of *The Artist's Magazine* on newsstands, or visit artistsnetwork.com.

These and other fine North Light products are available at your favorite art & craft retailer, bookstore or online supplier. Visit our websites at artistsnetwork.com and artistsnetwork.tv.

Follow North Light Books for the latest news, free wallpapers, free demos and chances to win FREE BOOKS!

Visit artistsnetwork.com and get Jen's North Light Picks!

Get free step-by-step demonstrations along with reviews of the latest books, videos and downloads from Jennifer Lepore, Senior Editor and Online Education Manager at North Light Books.

Get involved

Learn from the experts. Join the conversation on **Wet**Canvas